SWEDE ILLUSTRATIONS
Copyright © 2008 ARVINIUS FÖRLAG AB

Published in 2008 by:
Page One Publishing Private Limited
20 Kaki Bukit View
Kaki Bukit Techpark II
Singapore 415956
Tel: (65) 6742-2088
Fax: (65) 6744-2088
enquiries@pageonegroup.com
www.pageonegroup.com

Distributed by:
Page One Publishing Private Limited
20 Kaki Bukit View
Kaki Bukit Techpark II
Singapore 415956
Tel: (65) 6742-2088
Fax: (65) 6744-2088

First published 2008 by Arvinius Förlag AB

Text copyright © 2008 Arvinius Förlag AB
Images copyright © 2008 Arvinius Förlag AB
Design and layout copyright © 2008 Arvinius Förlag AB

Introduction: Alexandra Falagara
Translation of introduction: Joe Hewitt
Art Direction and design: Sandra Praun, Designstudio S
Cover design: Feng Dexian
Cover illustration: Sandra Isaksson

ISBN 978-981-245-338-9

Printed and bound in China

SWEDE ILLUSTRATIONS

CONTENTS

INTRODUCTION

"No man is an island, entire of itself; every man is a piece of the continent."
(John Donne 1624)

No illustrator is an island. They are affected by the age and society they live in. As they amass life experiences this affects their pictorial idiom and their ability to form associations, and they are affected by visual impressions just like everyone else.

Pictorial communication varies between countries and cultures; there are different schools and drawing traditions. What is "right" in one country can be "wrong" somewhere else. To some extent this will surely always be the case, but globalisation is dissolving national boundaries and these days we are influenced just as much by illustrators from other continents as by illustrators from our native countries. We can see that the world is growing. We have never had access to as many illustrations as we do now. New pictures, ideas and styles are spreading around the world like wildfire. On the internet there is a plethora of web sites, blogs and illustrator's forums where artists – amateurs and professionals alike – freely share their sketches and rough drafts for illustrations along with their private sketchbooks, full of their own projects. We can find tips on literature and links to favourite illustrators, and the online world's flat structure allows us to freely contribute whatever we like. Some people even upload pictures of their studios and drawing tables. So the conditions for communicating with the world are better than ever.

However, this isn't altogether a good thing. I recently heard about an illustrator who had bemoaned the constant networking on My-Space, and said that it had resulted in people stopping drawing. Instead they sat absorbed by their computers, looking at other illustrators' work. Considering the amount of pictures available it's hard to believe that this testimony is completely true. However, it is very likely that illustrators these days spend more time on sharing their work and making themselves visible than they did ten years ago. The solitary nature of the profession combined with the relatively new technology available has encouraged us to share our work. We can only guess how this will affect the actual drawing process. It is questionable whether it will really generate more paid work.

Leading illustrators use new methods and are inspired by other art forms, and they challenge prevailing ideas about what functional pictures should look like, turning them on their head. They inspire future illustrators and must count on being referred to more than once. At the speed that pictures are now spread around the world, one possible scenario is that drawing styles will be exhausted more quickly and there will be an increased risk of getting copied. This would mean that something seemingly unique is lost. However, the importance of daring to be generous with one's work must be stressed. Pictures are intended to be seen and although a style can be copied, an attitude to illustration cannot be plagiarized as easily – and an illustrator's work should always be in progress.

An illustrator creates pictures to say something. By illuminating a text with an editorial illustration or creating the silhouette of a collection in a fashion illustration, by drawing a political caricature or a dreamlike fairytale world in a children's picture book. It's about narrative and creating associations – and doing this using the illustrator's own voice. In an age when huge amounts of pictures are available, when style is often studied at the expense of content, it is more important than ever for illustrators to focus on the factors that make their work unique. Illustrators' greatest tool is

their ability to form associations and their way of visualising this. They use some of themselves in their work. We cannot and should not ignore the world around us but we must remember that "the individual style" is found beyond the surface. A unique illustration is characterised by a personal story.

No illustration is an island: it is directly related to its creator, to its context and to its intended audience. To read an illustration can be to recognize yourself, to take a walk through the gardens of your memories and use the references at your disposal to understand and interpret the picture. Some pictures might not be interpreted the way the illustrator wanted – and as an illustrator that's something you have to live with. An apple can always be viewed from several angles and a picture can never avoid having several different interpretations.

 This book presents 149 widely different illustrators. It's a collection full of impressions, which demands that you spend time with it. The pictures can change appearance depending on which mood you're in and what you have learned on that particular day. A picture that doesn't make much of an impression today can spark a revelation tomorrow. A low-key illustration can suddenly jump out and an apparently simple drawing can seem extremely complex. In some ways it can be problematic to take an illustration out of its context, as it can suddenly appear to be something that it isn't. Some pictures need a context while others work well on their own. Now they are also competing with each other for attention in this book. Bear in mind that the illustrations selected within are a little bit homeless and have been put in a completely new context, so take them as they are. *Swedish Illustration 2* can be used as a library of images to be inspired by, a collection of styles and techniques – and as a document of our times.

Alexandra Falagara
Illustrator

Marianne Adolfsson

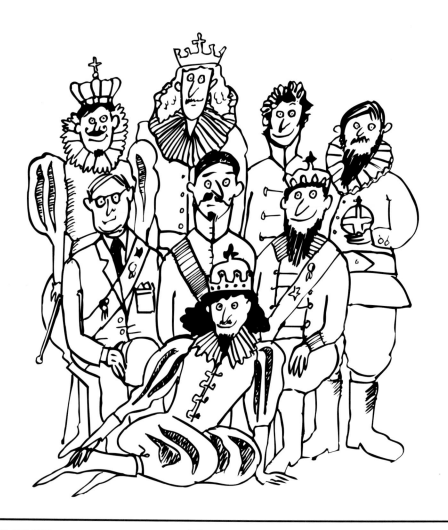

1

MARIANNE ADOLFSSON ILLUSTRATION & FORM **ADDRESS** ÅSÖGATAN 187, 4 TR, SE-116 32 STOCKHOLM, SWEDEN
PHONE +46 (0)8 702 08 17, +46 (0)70 572 20 81 **E-MAIL** MA.ILLFORM@SWIPNET.SE
SPECIALITY ADVERTISING, EDUCATIONAL MATERIAL, MAGAZINE ILLUSTRATION **CLIENTS** GLEERUPS UTBILDNING,
INVIVO COMMUNICATIONS, ALBERT BONNIERS FÖRLAG, BOKFÖRLAGET PRISMA, METRO

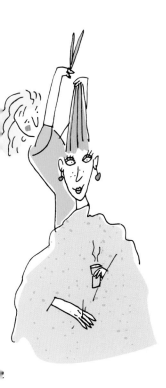

3

 1 CHILDREN'S BOOK. SEMIC FÖRLAG, 2006 2 WINDOW DISPLAY FOR HAIRDRESSING SALOON. PM STOCKHOLM, 2006
3 NEWSPAPER ILLUSTRATION. METRO, 2007

Jens Ahlbom

1

JENS AHLBOM ILLUSTRATÖR AB **ADDRESS** LAGMANSGATAN 14, SE-824 43 HUDIKSVALL, SWEDEN
PHONE +46 (0)650 146 91, +46 (0)70 714 12 00 **E-MAIL** JENS@AHLBOM.COM **WEBSITE** WWW.AHLBOM.COM
SPECIALITY BOOK ILLUSTRATION, CHILDREN'S BOOKS ILLUSTRATION, MAGAZINE ILLUSTRATION **CLIENTS** PAN VISION,
BOKFÖRLAGET NATUR & KULTUR, RABÉN & SJÖGREN, ALFABETA PUBLISHERS, ERIKSSON & LINDGREN BOKFÖRLAG

10

2

3

1 "LEJON PÅ STAN". CHILDREN'S BOOK. COVER. ERIKSSON & LINDGREN BOKFÖRLAG, 2006
2 CHARLES LINDBERGH. "BYGG FLYGPLAN MED MULLE MECK". COMPUTER GAME. PAN VISION, 2000
3 "BUILD CARS WITH GARY GADGET". COMPUTER GAME. COVER. VIVA MEDIA (NEW YORK), 2006

Åsa Alneng

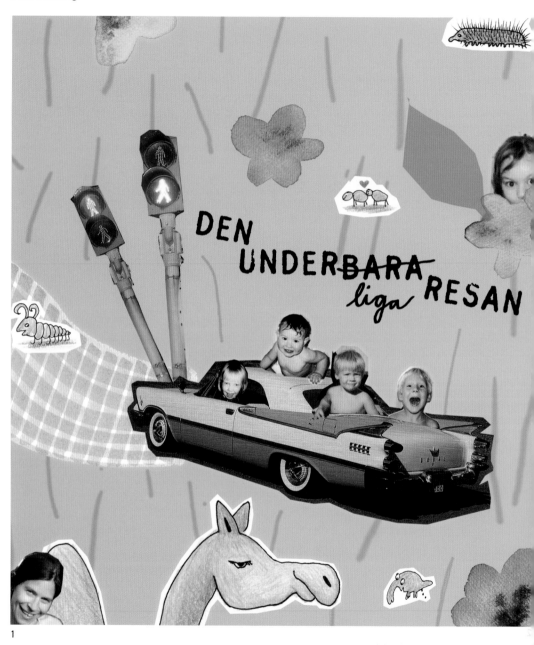

DEN UNDERBARA ~~BARA~~ liga RESAN

1

ÅSA ALNENG DESIGN **ADDRESS** STOLP-EKEBY 25, SE-186 95 VALLENTUNA, SWEDEN
PHONE +46 (0)8 512 304 00, +46 (0)70 897 63 36 **E-MAIL** ASA@NOEDESIGN.SE **WEBSITE** WWW.NOEDESIGN.SE
SPECIALITY BOOK COVERS, CHILDREN'S BOOKS ILLUSTRATION, GRAPHIC DESIGN **CLIENTS** NOE®, DIVA RECORDS,
FORMA PUBLISHING GROUP, AMMOT, BOKFÖRLAGET NATUR & KULTUR

1 "DEN UNDERLIGA RESAN". POSTER AND CD COVER. DIVA RECORDS, 2004
2 "HULLER OM BULLER MED TONE OCH POFF". CHILDREN'S BOOK. AMMOT, 2006

Christina Andersson

1

CHRISTINA ANDERSSON ILLUSTRATION **ADDRESS** SKÄLDERVIKSPLAN 16, SE-120 60 ÅRSTA, SWEDEN
PHONE +46 (0)8 641 32 10, +46 (0)73 378 04 42 **E-MAIL** 086413210@TELIA.COM **WEBSITE** WWW.CAND.JUST.NU
SPECIALITY EDUCATIONAL MATERIAL, ILLUSTRATING WEB PAGES AND MULTIMEDIA, MAGAZINE ILLUSTRATION
CLIENTS MAGAZINES, ADVERTISING AGENCIES, BOOK PUBLISHERS, PUBLIC AUTHORITIES, UNIONS

1 MAGAZINE ILLUSTRATION. TIDNINGEN BARN/SAVE THE CHILDREN, 2005

Kenneth Andersson

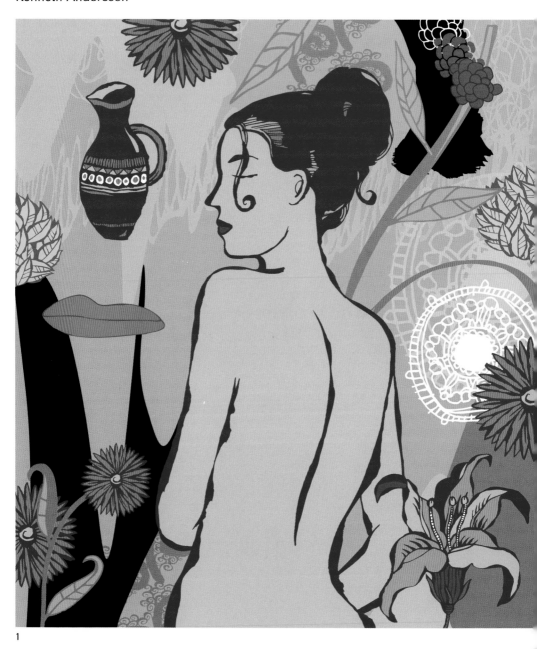

1

KENNETH ANDERSSON ILL&DESIGN AB **ADDRESS** STORA NYGATAN 44, SE-111 27 STOCKHOLM, SWEDEN
E-MAIL INFO@KENNETHANDERSSON.COM **WEBSITE** WWW.KENNETHANDERSSON.COM **PHONE** +46 (0)8 781 04 59,
+46 (0)70 834 37 42 **SPECIALITY** ADVERTISING, CHILDREN'S BOOKS, MAGAZINE ILLUSTRATION **CLIENTS** THE GUARDIAN,
TIME OUT, NEWSWEEK, RANDOM HOUSE, SVT **AGENCY** WWW.STOCKHOLMILLUSTRATION.COM, WWW.EYECANDY.CO.UK

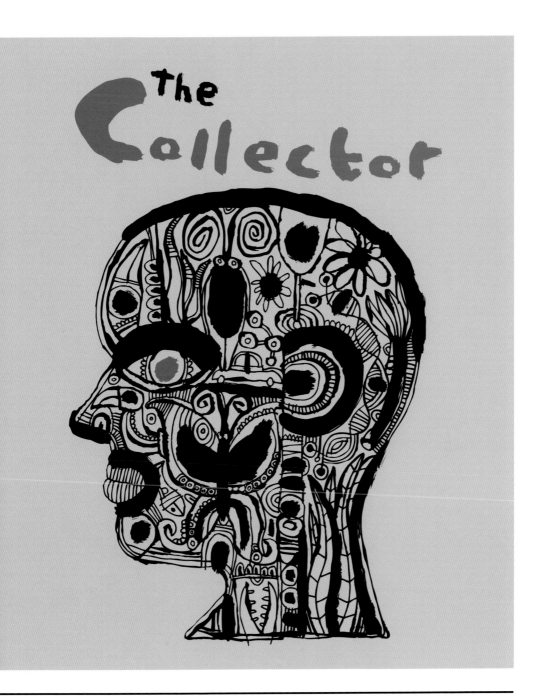

1 HEALTHY GIRL. MAGAZINE COVER. OCCUPATIONAL HEALTH MAGAZINE
2 THE CONNECTION BETWEEN COLLECTING THINGS AND CREATIVITY. CIVILINGENJÖREN

Hans Annell

1

ELUCIDO ILLUSTRATION & TEXT **ADDRESS** FURUSUNDSGATAN 12, SE-115 37 STOCKHOLM, SWEDEN
PHONE +46 (0)8 662 66 35, +46 (0)70 660 94 26 **E-MAIL** HANS.ANNELL@ELUCIDO.SE **WEBSITE** WWW.ELUCIDO.SE
SPECIALITY EDUCATIONAL MATERIAL, SUPPLYING BOTH ILLUSTRATION AND TEXT, TECHNICAL ILLUSTRATION
CLIENTS CASHGUARD, ELETTA FLOW, LORENTZEN & WETTRE, SCANIA, TIGERCAT

1 FOREST HARVESTER HEMEK H18 DRIVING ROPE. POSTER. TIGERCAT, 2001

2

3

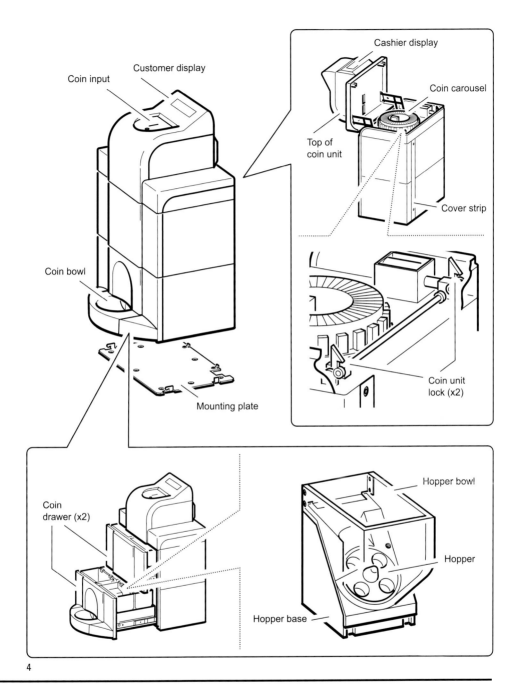

Coin input

Customer display

Cashier display

Coin carousel

Top of
coin unit

Cover strip

Coin bowl

Coin unit
lock (x2)

Mounting plate

Coin
drawer (x2)

Hopper bowl

Hopper

Hopper base

4

2 SAUNA WALL DETAILS. HOUSE DESIGN GUIDELINE. LOCAL CONTRACTOR, 2006
3 BRASS PROPELLER. BLACKLEAD. OWN PROJECT, 2000
4 OVERVIEW OF COIN CABINET. INSTALLATION GUIDE. CASHGUARD, 2004

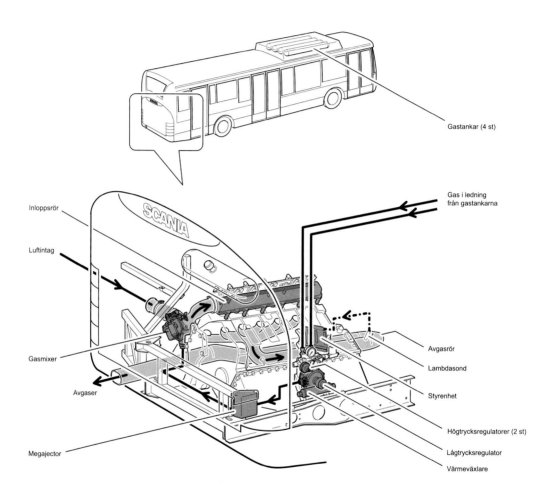

Gastankar (4 st)

Inloppsrör

Luftintag

Gas i ledning
från gastankarna

Gasmixer

Avgaser

Megajector

Avgasrör

Lambdasond

Styrenhet

Högtrycksregulatorer (2 st)

Lågtrycksregulator

Värmeväxlare

5

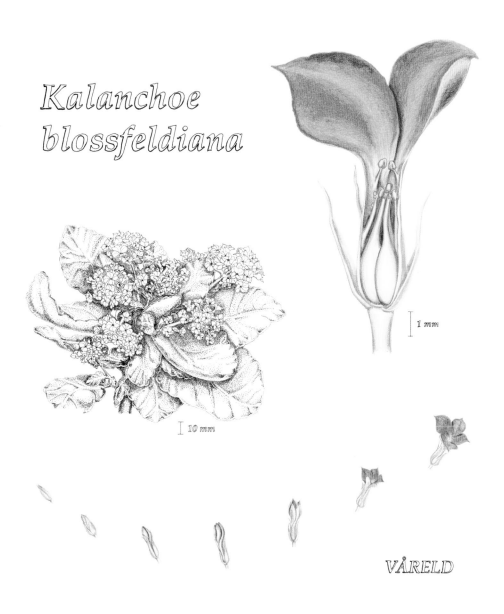

Kalanchoe blossfeldiana

1 mm

10 mm

VÅRELD

5 GAS SPECIFIC ENGINE COMPONENTS IN SCANIA OMNILINK GAS BUS. POSTER. SCANIA, 2005
6 KALANCHOE BLOSSFELDIANA. INK AND WATERCOLOUR PEN. OWN PROJECT, 2002

Tove Siri Antonsson

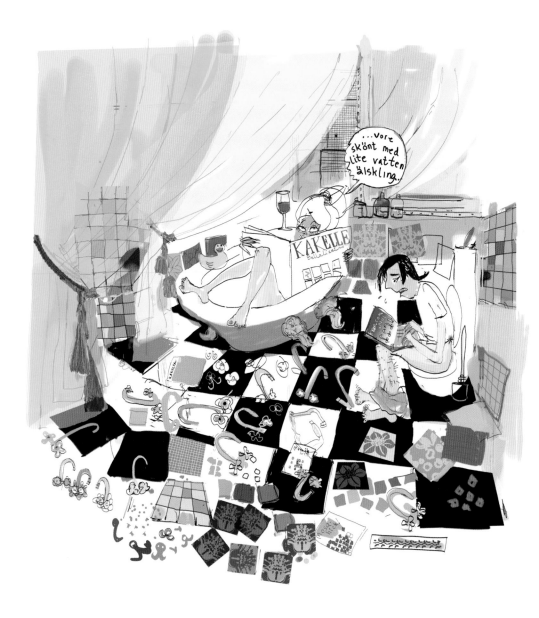

1

SIRISAN HB **ADDRESS** FAFNERVÄGEN 31, SE-182 66 DJURSHOLM, SWEDEN
PHONE +46 (0)8 544 979 99, +46 (0)70 846 71 51 **E-MAIL** TOVE@SIRISAN.SE **WEBSITE** WWW.TOVESIRI.COM
SPECIALITY ADVERTISING, CONCEPTUAL DRAWING, MAGAZINE ILLUSTRATION **CLIENTS** ELLE, TARA, AMELIA,
ERICSSON, THE SWEDISH GOVERNMENT

1 THE BATHROOM. ELLE INTERIÖR, 2007 2 NEVER GIVE UP. TARA, 2005

Hans Arnold

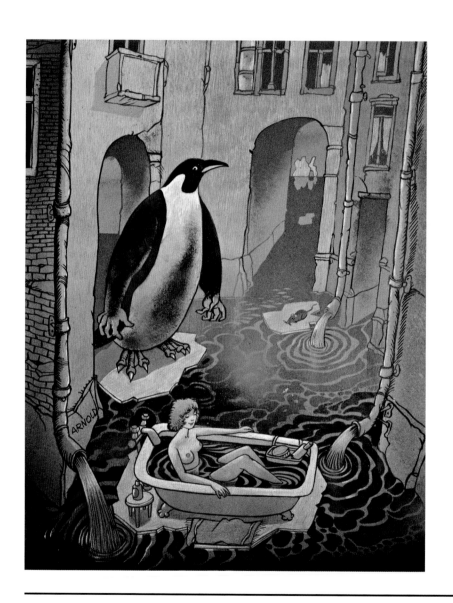

HANS ARNOLD **ADDRESS** KÅKBRINKEN 11 A, SE-111 27 STOCKHOLM, SWEDEN
PHONE +46 (0)8 21 37 99 **WEBSITE** WWW.HANSARNOLD.SE
SPECIALITY BOOK ILLUSTRATION, CHILDREN'S BOOKS ILLUSTRATION, SUPPLYING BOTH ILLUSTRATION AND TEXT

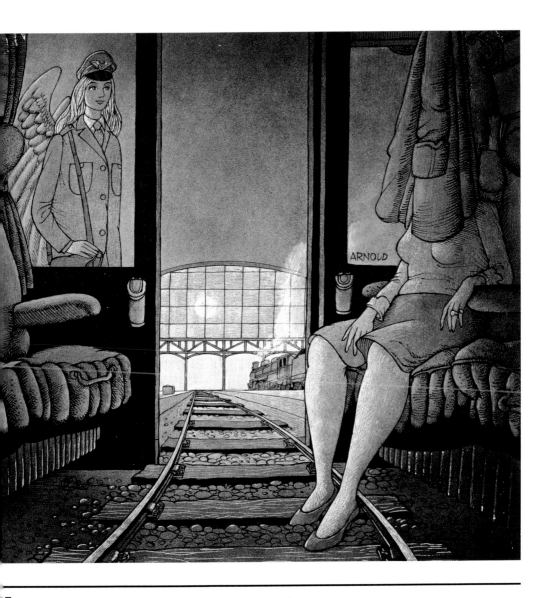

ARNOLD

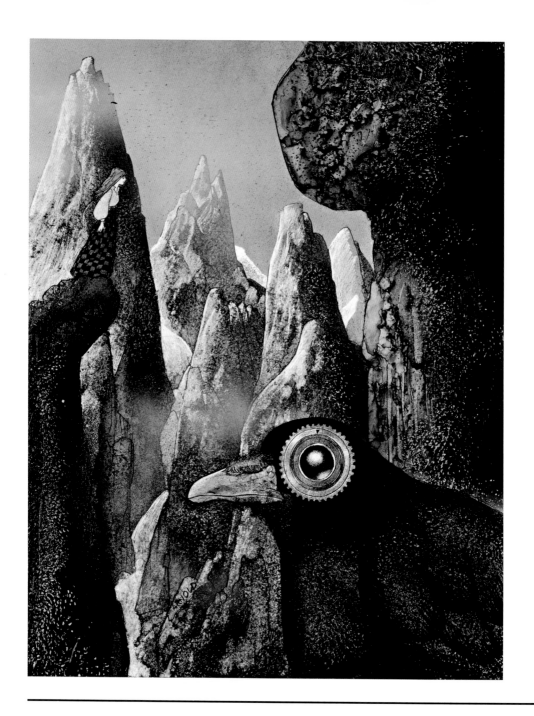

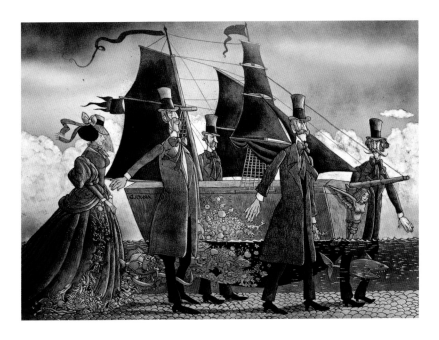

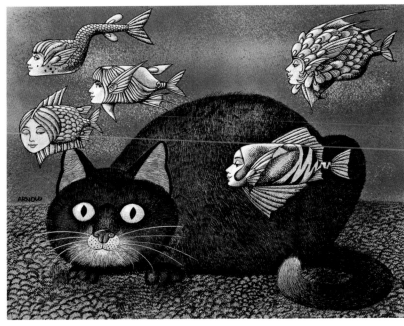

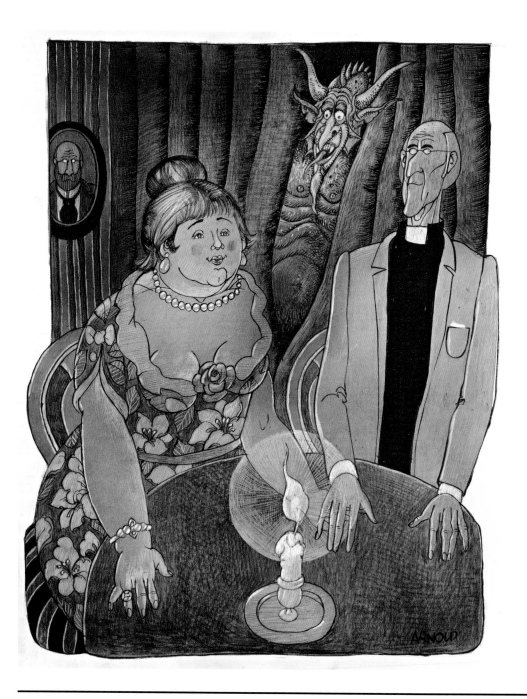

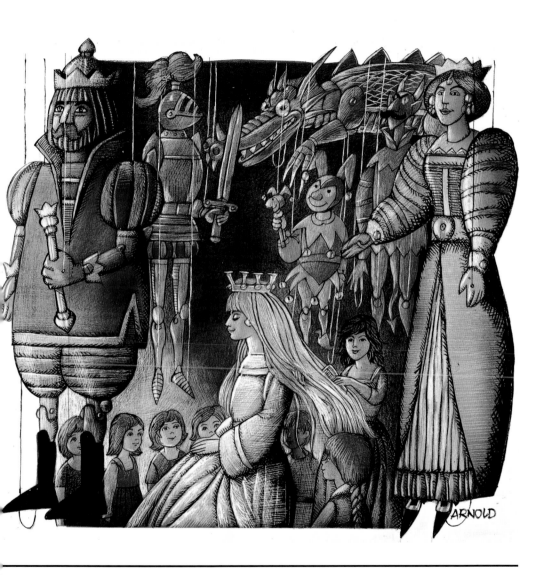

Lena Arvidsson Pape

1

LENA ARVIDSSON PAPE **ADDRESS** HÖGAGATAN 12, 460 65 BRÅLANDA, SWEDEN
PHONE +46 (0)521 194 56, +46 (0)73 996 13 80 **E-MAIL** LENAAPAPE@GMAIL.COM **WEBSITE** WWW.LAPAPE.SE
SPECIALITY CHILDREN'S BOOKS ILLUSTRATION, GRAPHIC DESIGN, MAGAZINE ILLUSTRATION **CLIENTS** LEO & MAJKEN,
BURNING HEART/EPITAPH RECORDS

2

3

1 OWN PROJECT, 2007 2 KID DOWN LABEL. GRAPHIC DESIGN. BURNING HEART/EPITAPH RECORDS, 2007
3 KID DOWN CD COVER INSERT. BURNING HEART/EPITAPH RECORDS, 2007

5

4 MAGAZINE ILLUSTRATION. LEO & MAJKEN, 2007
5 KID DOWN CD COVER. GRAPHIC DESIGN. BURNING HEART/EPITAPH RECORDS, 2007
6 KID DOWN CD BOOKLET. GRAPHIC DESIGN. BURNING HEART/EPITAPH RECORDS, 2007

Niklas Asker

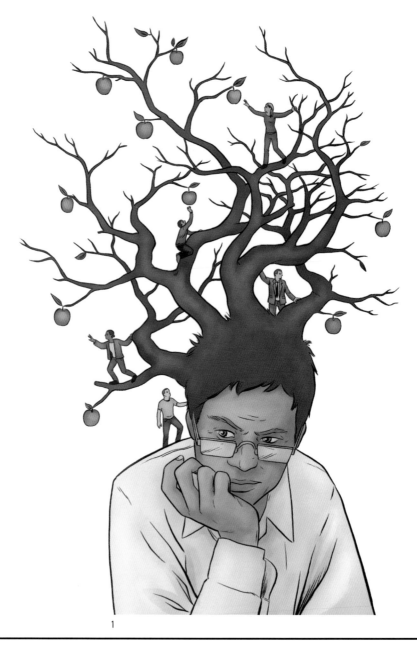

1

NIKLAS ASKER **ADDRESS** SÖDRA PARKGATAN 18 A, 214 22 MALMÖ, SWEDEN **VISITING** BERGSGATAN 29, MALMÖ
PHONE +46 (0)70 448 85 99 **E-MAIL** NIKLAS@NIKLASASKER.COM **WEBSITE** WWW.NIKLASASKER.COM
SPECIALITY BOOK COVERS, BOOK ILLUSTRATION, MAGAZINE ILLUSTRATION **CLIENTS** MICROSOFT, EMI MUSIC, IKEA,
DAZED & CONFUSED, APPELBERG PUBLISHING AGENCY

2

3

1 HOW IDEAS SPREAD AND GET STOLEN. T-TIME/APPELBERG PUBLISHING AGENCY, 2006
2 RZA FROM WO TANG CLAN. DAZED & CONFUSED, 2005 3 DAZED & CONFUSED, 2005

5

EXIT
A

6

4 MF DOOM AND DJ DANGERMOUSE COOPERATION. DAZED & CONFUSED, 2005 **5** RESPONSIBILITIES OF MAJOR COOPERATIONS WORKING IN POOR COUNTRIES. TETRA PAK/APPELBERG PUBLISHING AGENCY, 2007 **6** PRODUCTS MADE OF POLYMER-BASED MATERIALS. T-TIME/APPELBERG PUBLISHING AGENCY, 2006

Jürgen Asp

JÜRGEN ASP **ADDRESS** BERG 425, SE-444 95 ÖDSMÅL, SWEDEN **PHONE** +46 (0)303 899 22, +46 (0)70 877 37 14
E-MAIL JURGENASP.ATELJEN@TELIA.COM **WEBSITE** WWW.JURGENASP.COM **SPECIALITY** ADVERTISING, EDUCATIONAL
MATERIAL, MAGAZINE ILLUSTRATION

Leyla Atak

1

ATAK DESIGN & MEDIA **ADDRESS** DROTTNINGGATAN 21, SE-724 64 VÄSTERÅS, SWEDEN
PHONE +46 (0)21 41 40 20, +46 (0)70 671 68 48 **E-MAIL** LEYLA@ATAK.NU **WEBSITE** WWW.ATAK.NU
SPECIALITY ADVERTISING, EDUCATIONAL MATERIAL, MAGAZINE ILLUSTRATION **CLIENTS** THE SWEDISH NATIONAL AGENCY
FOR SCHOOL IMPROVEMENT, VÄSTERÅS & CO, 3S.T.E.G INTERNATIONAL, HJEM-IS NORDIC GROUP, FORMA PUBLISHING GROUP

2

3

1 CULTURAL ACTIVITIES FOR FAMILIES WITH CHILDREN. CULTUREN/THE INFORMATION BUREAU OFFICE OF VÄSTERÅS, 2007
2 OPPRESSION AND VIOLENCE IN THE NAME OF HONOUR. THE COUNTY ADMINISTRATIVE BOARD OF VÄSTMANLAND, 2006
3 ALONE – ABOUT INSURANCES. MAGAZINE ILLUSTRATION. VILLAÄGAREN/FORMA PUBLISHING GROUP, 2006

Jane Bark

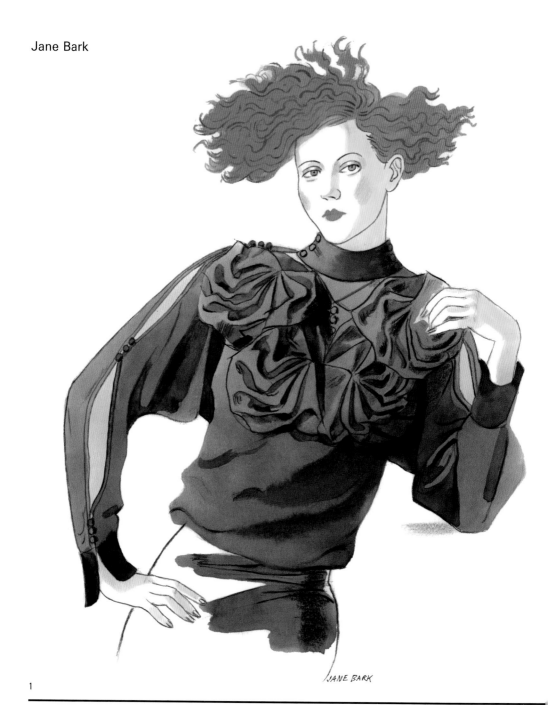

1

JANE BARK PRODUCTION **ADDRESS** BRAGEVÄGEN 21, SE-114 24 STOCKHOLM, SWEDEN
PHONE +46 (0)8 10 81 66, +46 (0)70 865 75 48 **E-MAIL** JANESTIG@TELIA.COM **SPECIALITY** FASHION ILLUSTRATION,
MAGAZINE ILLUSTRATION, PORTRAITS **CLIENTS** FOKUS MAGAZINE, DAGENS NYHETER, SKANSEN, POSTEN STAMPS,
BARKING DOG PUBLISHING

2

3

5 1 FASHION ILLUSTRATION. PLAZA MAGAZINE, 2006 2 PORTRAIT OF AUTHOR TORGNY LINDGREN. FOKUS MAGAZINE, 2006
3 PORTRAIT OF AUTHOR CARINA RYDBERG. FOKUS MAGAZINE, 2007

Helena Bergendahl

1

HELENA BERGENDAHL ILLUSTRATION **ADDRESS** C/O KNOCKOUT REPORTAGE, ANDRA LÅNGGATAN 20, SE-413 28 GÖTEBORG, SWEDEN **PHONE** +46 (0)31 711 99 77, +46 (0)70 328 77 98 **WEBSITE** WWW.HELENABERGENDAHL.BLOGSPOT.COM **E-MAIL** HELENA@KNOCKOUT.NU **SPECIALITY** CHILDREN'S BOOKS, CONCEPTUAL DRAWING, EDUCATIONAL MATERIAL **CLIENTS** DAGENS SAMHÄLLE, LIBER, H. ASCHEHOUG & CO, ALFABETA PUBLISHERS, KAMRATPOSTEN

4

2

3

1 HEALTH AND SAFETY IN WORKPLACES. TEXTBOOK ILLUSTRATION. PREVENT, 2006
2 THE IMPORTANCE OF GREEN AREAS IN URBAN PLANNING. MAGAZINE ILLUSTRATION. DAGENS SAMHÄLLE, 2006
3 ALIENATION IN MODERN CITIES. MAGAZINE ILLUSTRATION. DAGENS SAMHÄLLE, 2006

Pia Berglund

1

PIA BERGLUND **PHONE** +46 (0)73 821 42 72, **E-MAIL** PIA@PIABERGLUND.COM **WEBSITE** WWW.PIABERGLUND.COM
SPECIALITY CONCEPTUAL DRAWING, MAGAZINE ILLUSTRATION **CLIENTS** UPSALA NYA TIDNING, DU & JOBBET,
TIDNINGEN KULTUREN, A&N

the guinea pig
who thought
he was a bear.

or maybe the
drunk man
looking for some sex.

2

3

1 BIG WORDS. GRAPHITE AND COLLAGE. OWN PROJECT, 2006
2 THE SIMILARITIES. INK AND WATERCOLOUR. OWN PROJECT, 2006
3 FEMINISM. INK. TIDNINGEN KULTUREN, 2007

4

4 WITHOUT AIR. ENGRAVING. JOINT EXHIBITION, 2006 5 COMMUNICATION. INK AND COLLAGE. OWN PROJECT, 2007
6 INTERIOR DESIGN. INK AND COLLAGE. OWN PROJECT, 2007

Anna Björnström

1

ANNA BJÖRNSTRÖM FORM AB **ADDRESS** BARLOWS VÄG 1, SE-134 40 GUSTAVSBERG, SWEDEN
PHONE +46 (0)8 43 74 65 66, +46 (0)70 910 05 81 **E-MAIL** ANNA@GALLERIBARLOW.SE
WEBSITE WWW.BJORNSTROMFORM.SE, WWW.GALLERIBARLOW.SE **SPECIALITY** BOOK ILLUSTRATION,
GRAPHIC DESIGN, EDUCATIONAL MATERIAL **CLIENTS** BONNIER UTBILDNING, SIF, RFSL, LIBER

Ida Björs

1

IDA BJÖRS SUPERILLUSTRATION **ADDRESS** TEGELBRUKSVÄGEN 7, SE-126 32 HÄGERSTEN, SWEDEN
PHONE +46 (0)8 658 36 50, +46 (0)73 682 72 81 **E-MAIL** IDA@IDABJORSSUPERILLUSTRATION.SE
WEBSITE WWW.IDABJORSSUPERILLUSTRATION.SE **SPECIALITY** BOOK ILLUSTRATION, MAGAZINE ILLUSTRATION, PORTRAITS
CLIENTS DAGENS NYHETER, TIDNINGEN VI, ROYAL INSTITUTE OF TECHNOLOGY, FOLKTEATERN GÄVLEBORG, SVERIGES NATUR

1 ILLUSTRATION FOR THE POEM "VINTERORGEL". TIDNINGEN VI, 2006
2 "BOTILDA BENGTSSON OCH DEN DÄR SOFI". CHILDREN'S BOOK. ALFABETA PUBLISHERS, 2007

Uno Blaesild

1

SNABEL DESIGN **ADDRESS** VADENSJÖVÄGEN 96, SE-261 91 LANDSKRONA, SWEDEN
PHONE +46 (0)418 43 21 17, +46 (0)73 328 01 55 **E-MAIL** SNABEL-D@ALGONET.SE
WEBSITE WWW.SNABEL-DESIGN.SE **SPECIALITY** ADVERTISING, ANIMATION, TECHNICAL ILLUSTRATION

1 PACKAGING. BOSTIK FINDLEY, 2005
2 ANIMATED CHARACTERS. NON SMOKING MOVIE. MEDIX, 2007

Anette Blåberg

1

ANETTE BLÅBERG ILLUSTRATION **ADDRESS** NÄSBY ALLÉ 53, SE-183 55 TÄBY, SWEDEN
PHONE +46 (0)8 54 47 10 30, +46 (0)70 499 03 00 **E-MAIL** ANETTE.BLABERG@TELIA.COM
WEBSITE WWW.ILLUSTRATORCENTRUM.SE/ANETTE.BLABERG **SPECIALITY** ADVERTISING, BOOK ILLUSTRATION,
EDUCATIONAL MATERIAL **CLIENTS** PÅTIDEN PRODUKTION, HÖGANÄS, LIBER, BOKFÖRLAGET NATUR & KULTUR

2

3

1 MAGNOLIA. OWN PROJECT, 2006 2 "HJÄLP, JAG ÄR MED TRÄDGÅRD! EN GUIDE GENOM ÅRETS ALLA MÅNADER". PÅTIDEN PRODUKTION, 2006 3 "SÅ FINT!" SEEDING POTS AND TAGS. PÅTIDEN PRODUKTION, 2007

Annie Boberg

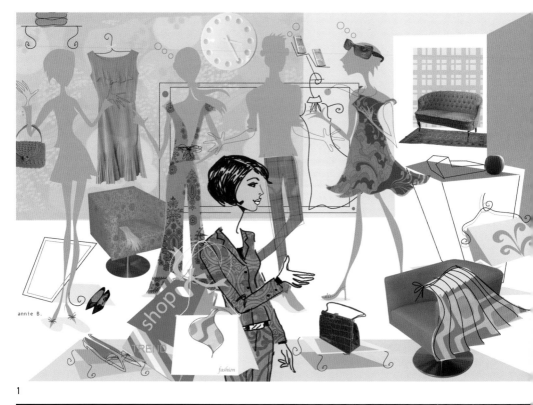

1

BOBERG BACKMAN KONSULT AB **ADDRESS** SKEPPARKROKEN 3, SE-181 66 LIDINGÖ, SWEDEN
PHONE +46 (0)8 767 88 39, +46 (0)70 867 42 35 **E-MAIL** ANNIE@ANNIE-B.COM **WEBSITE** WWW.ANNIE-B.COM
SPECIALITY BOOK COVERS, FASHION ILLUSTRATION, MAGAZINE ILLUSTRATION **CLIENTS** CHEF, ICA, ELLE INTERIOR, OXFORD
UNIVERSITY PRESS, FORUM/DN PUBLISHING HOUSE **AGENCY** THE ORGANISATION (UK)

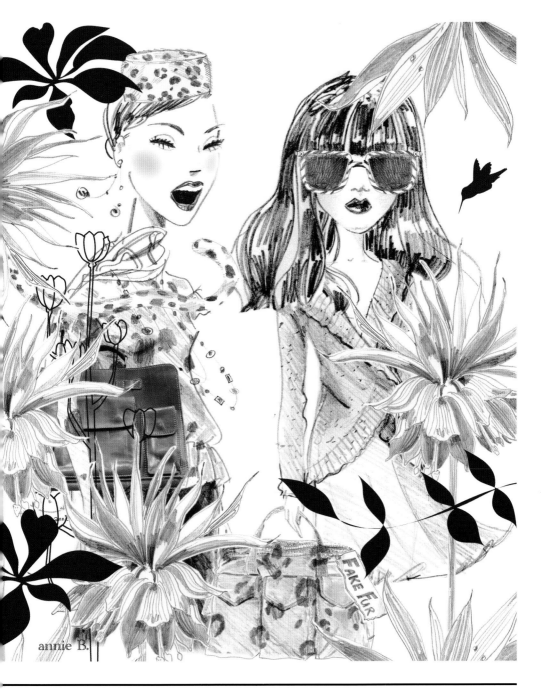

1 MIXED MEDIA ILLUSTRATION. SELF PROMOTION, 2006
2 COLLAGE INCLUDING PART OF A MAGAZINE ILLUSTRATION FOR CHEF, THE POCKETGUIDE, 2007

Rikard Bodin

1

TECKNARE RIKARD BODIN **ADDRESS** SELMEDALSRINGEN 9, SE-129 36 HÄGERSTEN, SWEDEN
PHONE +46 (0)8 19 46 36, +46 (0)70 734 88 16 **E-MAIL** RIKARD@RIKARDBODIN.SE **WEBSITE** WWW.RIKARDBODIN.SE
SPECIALITY FACTUAL GRAPHICS, EDUCATIONAL MATERIAL, MAGAZINE ILLUSTRATION **CLIENTS** TV4, AFTONBLADET,
GLEERUPS UTBILDNING, HAGSTRÖMER & QVIBERG, OKQ8

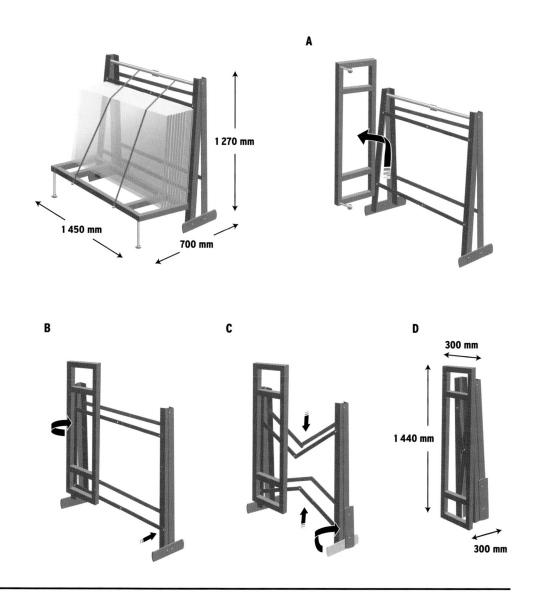

A

1 270 mm

1 450 mm

700 mm

B

C

D

300 mm

1 440 mm

300 mm

1 MR. HANSON. PROMOTION FOR HARDWARE STORE. MCLAIN PRODUCTION, 2005
2 PLOCKPAC. DATA AND DISMOUNT FUNCTIONS. UPC, 2006

Kristofer Bohlin

1 2

KRISTOFER BOHLIN ILLUSTRATION & DESIGN **ADDRESS** STORA BADHUSGATAN 30, SE-411 21 GÖTEBORG, SWEDEN
PHONE +46 (0)31 13 09 43, +46 (0)73 051 79 05 **E-MAIL** KRISTOFER@KRISTOFERBOHLIN.COM
WEBSITE WWW.KRISTOFERBOHLIN.COM **SPECIALITY** ADVERTISING, ILLUSTRATING WEB PAGES AND MULTIMEDIA,
MAGAZINE ILLUSTRATION **CLIENTS** FORMA PUBLISHING GROUP, IDG, SKÖNA HEM, VATTENFALL

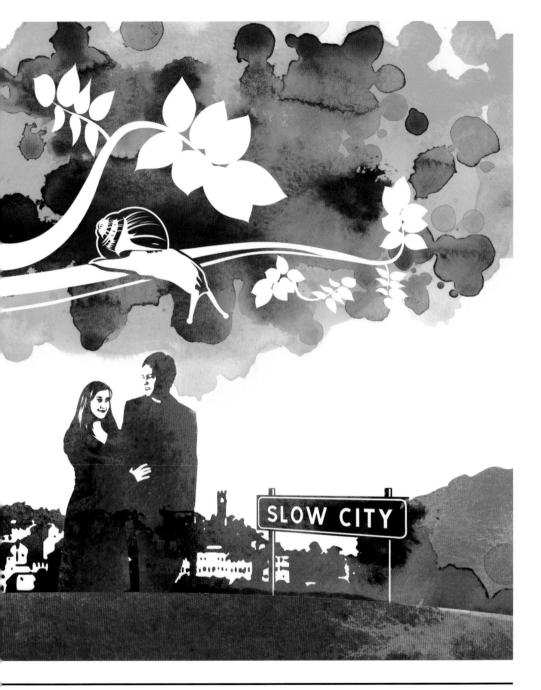

SLOW CITY

1 THEME ILLUSTRATION. CLUB GUIDE KALENDARIUM **2** THEME ILLUSTRATION. CLUB GUIDE KALENDARIUM
3 SLOW LIVING. MAGAZINE ILLUSTRATION. SKÖNA HEM

4

5

Janette Bornmarker

1

JABO ILLUSTRATION **ADDRESS** STOCKHOLM ILLUSTRATION, STORA NYGATAN 44, SE-111 27 STOCKHOLM, SWEDEN
PHONE +46 (0)8 22 22 24 **E-MAIL** JANETTE@STOCKHOLMILLUSTRATION.COM **WEBSITE** WWW.STOCKHOLMILLUSTRATION.COM
SPECIALITY ADVERTISING, BOOK ILLUSTRATION, MAGAZINE ILLUSTRATION **CLIENTS** STOCKHOLM COUNTY COUNCIL,
SVERIGES UTBILDNINGSRADIO, ÅHLÉNS, BOKFÖRLAGET NATUR & KULTUR, BONNIER TIDSKRIFTER

1 SELF PROMOTION, 2006 2 "TID FÖR FIKA". BOOK. STOCKHOLM ILLUSTRATION, 2006

Lotta Bruhn

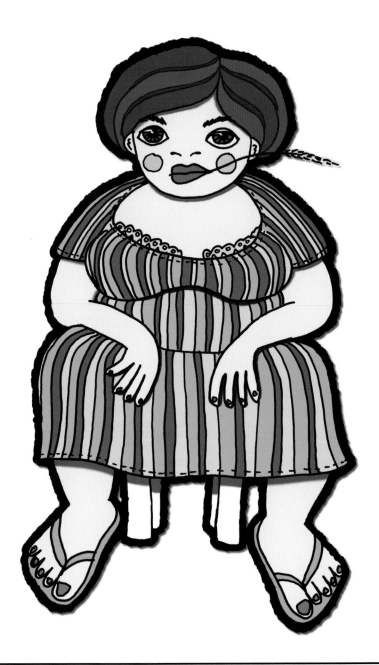

LOTTA BRUHN **ADDRESS** AMIRALSGATAN 16, SE-211 55 MALMÖ, SWEDEN
PHONE +46 (0)70 995 06 38 **E-MAIL** LOTTA@BRUHNFAMILY.COM **WEBSITE** WWW.BRUHNFAMILY.COM
SPECIALITY CHILDREN'S BOOKS ILLUSTRATION, LOGOTYPES, MAGAZINE ILLUSTRATION **CLIENTS** MCCANN, FILM I SKÅNE,
ÅKESSON & CURRY, FOUNTAIN, WAX PARTNERSHIP

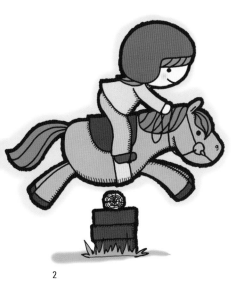

2

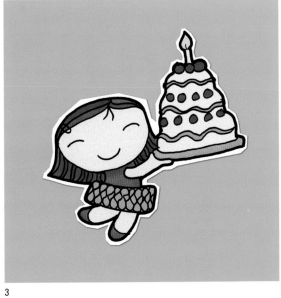

3

1

1 WOMAN ON STOOL. POSTER. MAGMA, 2006
2 GIRL AND PONY. CHARACTERS FOR CHILDREN'S BOOK. BRUHN PUBLISHING, 2006
3 GIRL WITH CAKE. BIRTHDAY CARD, 2006

Petra Bush

1

BUSH PRODUCTION **ADDRESS** VÄSTRA STORGATAN 53, SE-646 35 GNESTA, SWEDEN
PHONE +46 (0)158 141 41, +46 (0)70 788 37 71 **E-MAIL** PETRA@BUSHPRODUCTION.COM
WEBSITE WWW.BUSHPRODUCTION.COM **SPECIALITY** ADVERTISING, FASHION ILLUSTRATION, MAGAZINE ILLUSTRATION
CLIENTS ÅHLÉNS, ELLE, COOP, FILIPPA K, H&M

1 WEBSITE. DISA SWEDEN, 2007 **2** RICECAKE PACKAGE FOR FRIGGS. YTTERBORN & FUENTES, 2006

5

3 JUNGLE. CHILDREN´S COLLECTION FOR ÅHLÉNS, 2006
4 ELLE LYX SWEDEN, 2007 5 ELLE SWEDEN, 2006

Lilian Bäckman

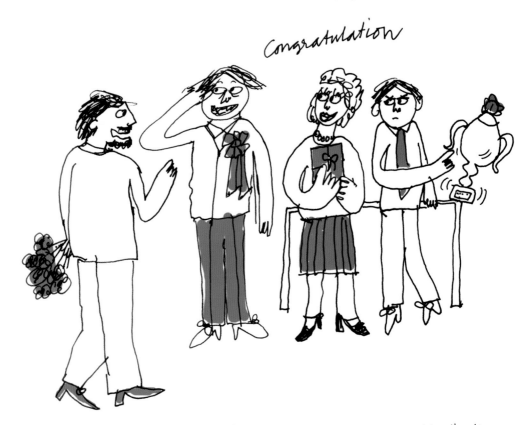

HEREBY I APPOINT YOU TO:

H.C.E.T.E. O.T. W.A.T.B.O.T.B.I.D.
O.E.A.I.B.F.M.Y.A.T.B.*

Congratulation

* Human Capital Expatriate Tax expert of the world and the best of the best in direction
universe. OK everybody are important, but for the moment you are the BEST

1

LILIAN BÄCKMAN (LIBÄ) ADDRESS KUNGSHOLMS KYRKOPLAN 6, SE-112 24 STOCKHOLM, SWEDEN
PHONE +46 (0)8 652 65 75, +46 (0)70 660 33 61 E-MAIL LILIANBACKMAN@LIBA.NU, WEBSITE WWW.LIBA.NU
SPECIALITY ADVERTISING, GRAPHIC DESIGN, SUPPLYING BOTH ILLUSTRATION AND TEXT
CLIENTS BLOCK 116, FRÄULINE DESIGN, FORUM, TCO, WAHLSTRÖM & WIDSTRAND

2

3

1 "VÅRA VÄRDERINGAR". ILLUSTRATION AND TEXT. ERNST & YOUNG, 2004
2 "XISTMODELLEN – FÖRÄLDRAUTBILDNING FÖR UNGA GRAVIDA". ILLUSTRATION AND TEXT. STIFTELSEN KVINNOFORUM, 2006
3 "GOD MORGON VÄRLDEN – RÅDSLAG OM DET NYA ARBETSLIVET". ILLUSTRATION AND TEXT. TCO, 2006

DIPLOMA

Coming Out

DIPLOMA

Coming Out

Coming Out

DIPLOMA

Coming Out

Coming Out

DIPLOMA

Coming Out

DIPLOMA

GOOD LUCK AND

WISHES FROM:

A DIPLOMA FOR:

The

AFTER

A

HAPPY

OUT-

COMMING

FROM

THE

WARD-

ROBE

Coming Out

DIPLOMA

Coming Out

DIPLOMA

Coming Out

DIPLOMA

Coming Out

DIPLOMA

Coming Out

DIPLOMA

Coming Out

DIPLOMA

Coming Out

GOOD LUCK AND
WISHES FROM:

A DIPLOMA FOR:

The

AFTER
A
HAPPY

OUT-
COMMING

FROM
THE
WARD-
ROBE

Anna Cederberg

1

NAUSIKAA FORM OCH ILLUSTRATION **ADDRESS** BORGARGATAN 8, NB, SE-117 34 STOCKHOLM, SWEDEN
PHONE +46 (0)70 910 38 21 **E-MAIL** ANNA@NAUSIKAA.COM **WEBSITE** WWW.NAUSIKAA.COM
SPECIALITY ADVERTISING, BOOK COVERS, ILLUSTRATING WEB PAGES AND MULTIMEDIA **CLIENTS** COOP, RFSU, RÅD & RÖN,
VÅRDGUIDEN, ÖHRLINGS PRICEWATERHOUSECOOPERS

2

3

1 THE BRAND IS MY GREATEST ASSET. AGENDA/ÖHRLINGS PRICEWATERHOUSECOOPERS, 2006
2 I'M 2 YEARS OLD. CHILDREN'S BOOK. OWN PROJECT, 2007 **3** LET'S TALK ABOUT MEN. RFSU, 2004

Clas Celsing

1

CLAS CELSING PRODUKTION **ADDRESS** NATHORSTVÄGEN 11, SE-121 37 JOHANNESHOV, SWEDEN
PHONE +46 (0)8 39 19 25, +46 (0)70 979 77 53 **E-MAIL** CLAS@CLASCELSINGBAND.SE
SPECIALITY CARTOONS, GRAPHIC DESIGN **CLIENTS** POND DESIGN AGENCY

1 CARTOON. SCHOOL APPLICATION. KONSTFACK UNIVERSITY COLLEGE OF ARTS, CRAFTS AND DESIGN, 2007
2 CARTOON. SCHOOL APPLICATION. KONSTFACK UNIVERSITY COLLEGE OF ARTS, CRAFTS AND DESIGN, 2007

3 CARTOON. SCHOOL APPLICATION. KONSTFACK UNIVERSITY COLLEGE OF ARTS, CRAFTS AND DESIGN, 2007
4 CARTOONS. PACKAGING. KRAFT FOODS, 2007

Jonn Clemente

1

JONN CLEMENTE ILLUSTRATION **ADDRESS** MAGNUS LADULÅSGATAN 25, SE-118 65 STOCKHOLM, SWEDEN
PHONE +46 (0)73 245 82 01 **E-MAIL** MAIL@JONNCLEMENTE.SE **WEBSITE** WWW.JONNCLEMENTE.SE
SPECIALITY ANIMATION, FACTUAL GRAPHICS, ILLUSTRATING WEB PAGES AND MULTIMEDIA
CLIENTS ALBERT BONNIERS FÖRLAG, EXTRALIVES, EXPRESSEN, LUPO DESIGN, MARKET

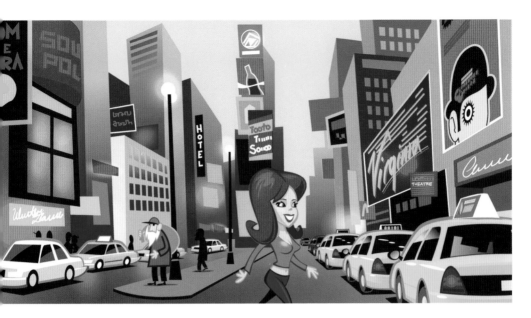

1 CHARACTERS. "POPOMUNDO". ONLINE GAME. EXTRALIVES, 2007
2 NEW YORK. "POPOMUNDO". ONLINE GAME. EXTRALIVES, 2007
3 BERLIN. "POPOMUNDO". ONLINE GAME. EXTRALIVES, 2007

Pia Crafoord

1

PIA CRAFOORD **ADDRESS** WIP:STHLM, ÅRSTA SKOLGRÄND 12 B, SE-117 43 STOCKHOLM, SWEDEN
PHONE +46 (0)70 715 54 14 **E-MAIL** PIACRAFOORD@HOTMAIL.COM **WEBSITE** WWW.WIPSTHLM.SE
SPECIALITY SUPPLYING BOTH ILLUSTRATION AND TEXT **CLIENTS** THE STOCKHOLM CITY THEATRE, BANG,
ETIKANALYTIKERNA, DAGENS NYHETER

1

1 GOOD MORNING. DIGITAL LITHOGRAPH. OWN PROJECT, 2006
2 REST. DIGITAL LITHOGRAPH FOR THE PLAY "FLICKAN/SKULDEN". THE STOCKHOLM CITY THEATRE, 2005
3 SPRING FEVER. DIGITAL LITHOGRAPH. SKÖNA HEM, 2007

Beatrice Csontos-Vidén

1

LEVITATE DESIGN **ADDRESS** VASAGATAN 40, BOX 804, SE-101 36 STOCKHOLM, SWEDEN
PHONE +46 (0)8 545 225 47, +46 (0)73 092 25 47 **E-MAIL** BEATRICE.CSONTOS@GMAIL.COM
SPECIALITY FASHION ILLUSTRATION, GRAPHIC DESIGN, PORTRAITS **CLIENTS** KAIROS FUTURE, OHIO UNIVERSITY,
VISION ÖRESUND, SONY ERICSSON, LOTUS TRAVEL

2

1 MARIE LAVEAU AS A CHILD. MIXED MEDIA PORTRAIT. ART EXHIBITION "GONE TO PATAGONIA", 2006
2 SPACE WALES. WATERCOLOUR. CURRENT CHILDREN'S BOOK PROJECT, 2006

Helena Davidsson Neppelberg

HELENA DAVIDSSON NEPPELBERG **ADDRESS** TALLKROGSVÄGEN 60, SE-122 39 ENSKEDE, SWEDEN
PHONE +46 (0)8 600 40 47, +46 (0)70 606 40 47 **E-MAIL** DAVIDSSON.NEPPELBERG@TELIA.COM
WEBSITE WWW.DAVIDSSON-NEPPELBERG.SE **SPECIALITY** MAGAZINE ILLUSTRATION, CHILDREN'S BOOKS ILLUSTRATION,
CONCEPTUAL DRAWING **CLIENTS** TIDNINGEN VI, DAGENS NYHETER, ALFABETA PUBLISHERS, RABÉN & SJÖGREN, LL-FÖRLAGET

1 LOG OF WOOD. DAGENS NYHETER, 2006 2 ANGER. OWN PROJECT, 2007

Edvard Derkert

1

EDVARD DERKERT **ADDRESS** MASKINISTGATAN 3, SE-117 66 STOCKHOLM, SWEDEN
PHONE +46 (0)8 645 86 98, +46 (0)76 858 58 62 **E-MAIL** EDVARD@DAD.A.SE **WEBSITE** WWW.DAD.A.SE
SPECIALITY BOOK COVERS, CONCEPTUAL DRAWING, GRAPHIC DESIGN **CLIENTS** ALBERT BONNIERS FÖRLAG, AFTONBLADET,
TIDNINGEN VI, BOKFÖRLAGET NATUR & KULTUR, ORDFRONT MAGASIN

1 FOLKLORE. NATIONALGALLERIET, 2007 2 NO TITLE. NATIONALGALLERIET, 2007

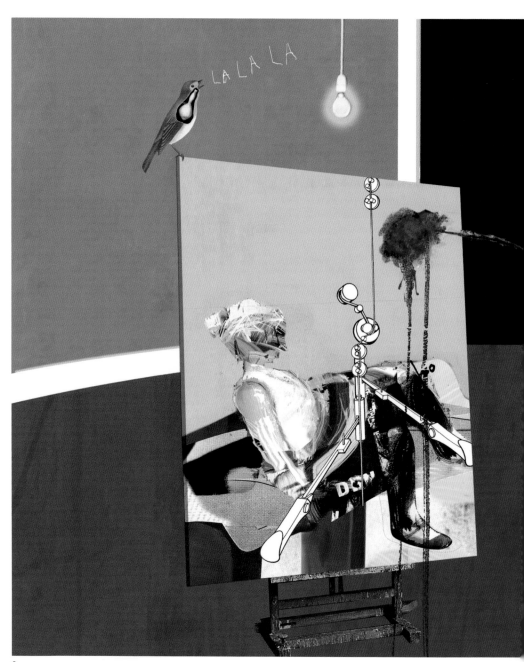

LA LA LA

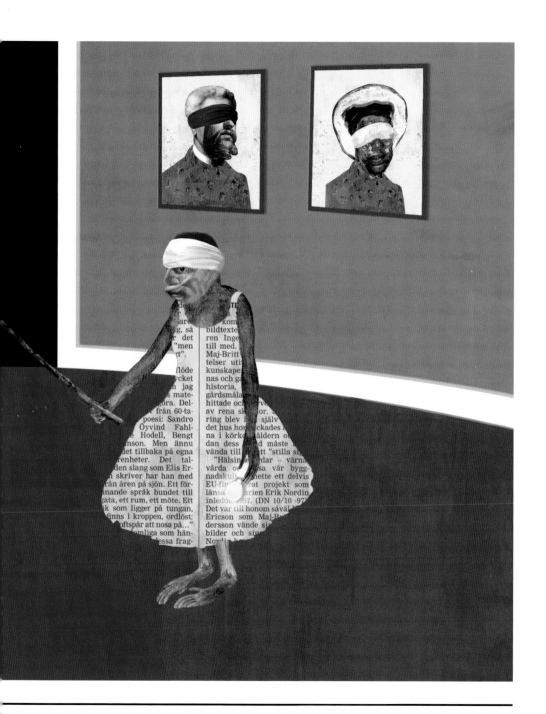

Lene Due-Jensen

1

LENE DUE-JENSEN ILLUSTRATÖR **ADDRESS** STORA BADHUSGATAN 30, SE-413 11 GÖTEBORG, SWEDEN
PHONE +46 (0)31 13 09 43, +46 (0)70 747 50 91 **E-MAIL** LENE@BADHUSGATAN.COM **WEBSITE** WWW.BADHUSGATAN.COM
SPECIALITY ADVERTISING, FASHION ILLUSTRATION, MAGAZINE ILLUSTRATION **CLIENTS** HAPPY F&B, THE SWEDISH MUSEUM
OF ARCHITECTURE, FOLKSAM

1 MAGAZINE ILLUSTRATION. HELSINGBORGS DAGBLAD, 2007
2 PART OF GRAPHIC IDENTITY FOR GÖTEBORGSPOSTEN. HAPPY F&B, 2005
3 ILLUSTRATION. FOLKSAM, 2007

Johnny Dyrander

1

JOHNNY DYRANDER BILD & FORM **ADDRESS** KATARINA BANGATA 29, BV, SE-116 39 STOCKHOLM, SWEDEN
PHONE +46 (0)8 643 92 20, +46 (0)70 694 85 40 **E-MAIL** JOHNNY@DYRANDER.SE **WEBSITE** WWW.DYRANDER.SE
SPECIALITY ADVERTISING, EDUCATIONAL MATERIAL, MAGAZINE ILLUSTRATION **CLIENTS** TELIASONERA,
MINISTRY OF FINANCE, ALECTA, LIBER, BOKFÖRLAGET NATUR & KULTUR

2

3

1 SYMBOLS. LULEÅ ENERGI, 2007 **2** KAROLINSKA UNIVERSITY HOSPITAL, 2006
3 KAROLINSKA UNIVERSITY HOSPITAL, 2007

Kicki Edgren Nyborg

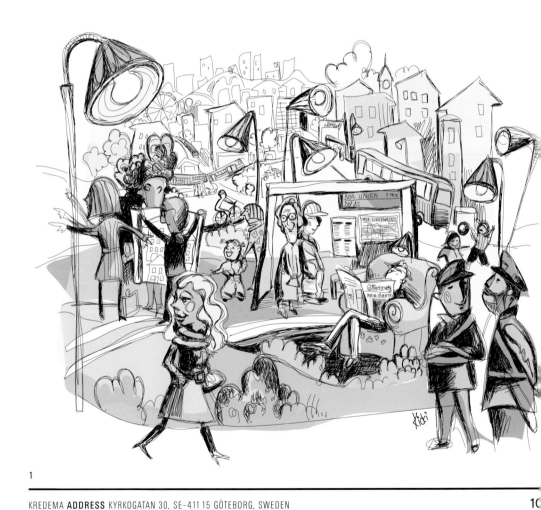

1

KREDEMA **ADDRESS** KYRKOGATAN 30, SE-411 15 GÖTEBORG, SWEDEN
PHONE +46 (0)70 521 64 49 **E-MAIL** KICKI@KREDEMA.SE **WEBSITE** WWW.KREDEMA.SE
SPECIALITY ADVERTISING, BOOK COVERS, MAGAZINE ILLUSTRATION **CLIENTS** VOLVO, LINDEX, WALLENSTAM,
ALBERT BONNIERS FÖRLAG, TWILFIT

2

3

1 SERVEY GOTHENBURG. MAGAZINE ILLUSTRATION. VÅRT GÖTEBORG/CITY OF GÖTEBORG, 2007
2 RECRUIT PROCESS. PART OF A SERIES OF ILLUSTRATIONS. LINDEX, 2005
3 GENERATIONS. VOLVO TRUCKS – GLOBAL, 2006

Jan Edlund

1

JAN EDLUND **ADDRESS** VERKSTADSGATAN 9, SE-117 36 STOCKHOLM, SWEDEN
PHONE +46 (0)70 710 33 39 **E-MAIL** JANNE.EDLUND@SWIPNET.SE **WEBSITE** WWW.JANEDLUND.SE
SPECIALITY MAGAZINE ILLUSTRATION, BOOK ILLUSTRATION, EDUCATIONAL MATERIAL
CLIENTS LIBER, STOCKHOLM COUNTY COUNCIL, BOKFÖRLAGET NATUR & KULTUR, FÖRSKOLAN, GODA GRANNAR

1 "CAMINANDO". SPANISH TEXTBOOK. BOKFÖRLAGET NATUR & KULTUR, 2006
2 SHORT STORY BY JOHANNA NILSSON. BOKFÖRLAGET NATUR & KULTUR, 2006
3 LOW WATER. DOCUMENTARY ON A BIKE TOUR, 2005

Lena Edselius

1

IKIOMA ILLUSTRATION **ADDRESS** KÄRLEKSSTIGEN 23, SE-952 32 KALIX, SWEDEN
PHONE +46 (0)923 105 33, +46 (0)70 239 44 27 **E-MAIL** LENA.EDSELIUS@TELIA.COM
SPECIALITY BOOK ILLUSTRATION, PORTRAITS, POSTCARDS AND POSTERS **CLIENTS** COUNTY ADMINISTRATIVE BOARD OF
NORRBOTTEN, MUNICIPAL LIBRARY OF KALIX, SANA ARBETSLIVSTJÄNST, SOCIALDEMOKRATISKA KOMBILOTTERIET, VATTENFALL

9

1 BATHING LADIES/JANUARY. CALENDAR ILLUSTRATION. SOCIALDEMOKRATISKA KOMBILOTTERIET, 2006
2 OUTSIDERS. JOINT EXHIBITION AT NORRBOTTENS MUSEUM, 2006

Birgitta Edstrand

ACCENT REKLAM & ILLUSTRATION **ADDRESS** KORALLVÄGEN 34, SE-135 42 TYRESÖ, SWEDEN
PHONE +46 (0)8 712 77 91, +46 (0)73 510 92 08 **E-MAIL** BIRGITTA.EDSTRAND@TELIA.COM
SPECIALITY GRAPHIC DESIGN, LOGOTYPES, MAGAZINE ILLUSTRATION **CLIENTS** INNOVATIONSBRON UPPSALA,
TYRIT WINCH ENGINE, NOAX SYS, PROKEM, KOMMUNAKTUELLT

3

1

1 A WINCH ENGINE WITH FOUR DIFFERENT USES. TYRIT WINCH ENGINE, 2007
2 BULLYING AT SCHOOL. MAGAZINE ILLUSTRATION. KOMMUNAKTUELLT, 2005
3 A MEETING. POSTER. INNOVATIONSBRON UPPSALA, 2006

Erika Eklund Wilson

1

ERIKA EKLUNDS ATELJÉ **ADDRESS** PLANETVÄGEN 2, SE-141 40 HUDDINGE, SWEDEN
PHONE +46 (0)8 711 36 03, +46 (0)70 441 21 11 **E-MAIL** POST@ERIKAEKLUND.SE **WEBSITE** WWW.ERIKAEKLUND.SE
SPECIALITY BOOK ILLUSTRATION, CHILDREN'S BOOKS ILLUSTRATION, EDUCATIONAL MATERIAL
CLIENTS LIBER, LL-FÖRLAGET, BOKFÖRLAGET NATUR & KULTUR, BONNIER CARLSEN, BARNENS BOKKLUBB

2

3

4 "HÅLL KOLL PÅ PENGARNA!". EASY-TO-READ BOOK. LL-FÖRLAGET, 2004
5-6 "LÄGG NÄSAN I BLÖT!". EASY-TO-READ BOOK. LL-FÖRLAGET, 2001

Catharina England

1

MARMALADE MOON **ADDRESS** ORVAR ODDS VÄG 10, SE-112 54 STOCKHOLM, SWEDEN
PHONE +46 (0)8 618 30 00 **E-MAIL** INFO@MARMALADEMOON.COM **WEBSITE** WWW.MARMALADEMOON.COM
SPECIALITY GRAPHIC DESIGN, ILLUSTRATING WEB PAGES AND MULTIMEDIA **CLIENTS** STOCKHOLM UNIVERSITY,
THE ICONFACTORY, THE DEMOCRATIC PARTY, FONT DINER, METRO-GOLDWYN-MAYER INC.

1 PRIVATE EYE ACT/COFFEE. THE ICONFACTORY, 2003 2 HIEROGLYPHICA. THE ICONFACTORY, 2006

3 IPHONICA. THE ICONFACTORY, 2007 **4** SOON SPRING/TULIP. THE ICONFACTORY, 2005

Camilla Engman

1

CAMILLA ENGMAN GRAFISK DESIGN OCH ILLUSTRATION **ADDRESS** PARADISGATAN 25 G, SE-413 16 GÖTEBORG, SWEDEN
PHONE +46 (0)73 679 36 36 **E-MAIL** CAMILLA@CAMILLAENGMAN.COM **WEBSITE** WWW.CAMILLAENGMAN.COM
SPECIALITY BOOK COVERS, MAGAZINE ILLUSTRATION, POSTCARDS AND POSTERS **CLIENTS** WALT DISNEY COMPANY,
NEW YORK TIMES, BOSTON GLOBE, BRITISH COLUMBIA AIRLINES, LIVING **AGENCY** MARLENA AGENCY, PHONE +1 609 252 9405

4

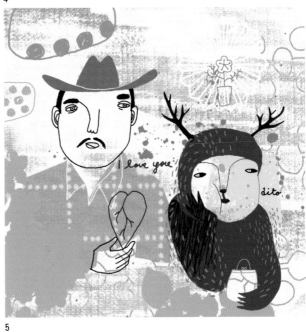

5

3 CALENDAR ILLUSTRATION. SELF PROMOTION, 2006 **4** MAGAZINE ILLUSTRATION. NEW YORK TIMES, 2006
5 PRINT. TINY SHOWCASE, 2006

Annsofi Ericsson Petrini

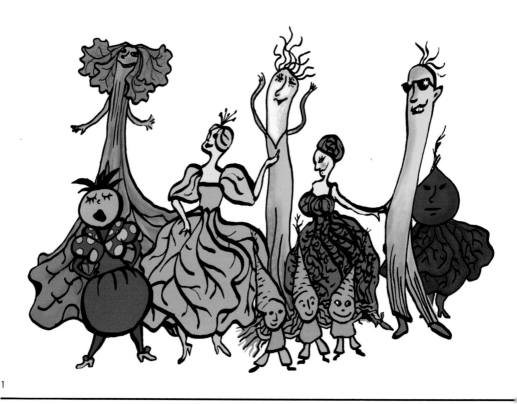

1

EKOGRAFILL AB **ADDRESS** NYGATAN 16, SE-647 30 MARIEFRED, SWEDEN
PHONE +46 (0)159 100 62, +46 (0)70 788 40 19 **E-MAIL** ANNSOFI@EKOGRAFILL.SE
SPECIALITY CONCEPTUAL DRAWING, GRAPHIC DESIGN, MAGAZINE ILLUSTRATION **CLIENTS** CONCERTS SWEDEN,
SVENSK BYGGTJÄNST, SÖRMLANDS MUSIK & TEATER, CAPRICE RECORDS, SÖRMLANDS MATKLUSTER

12

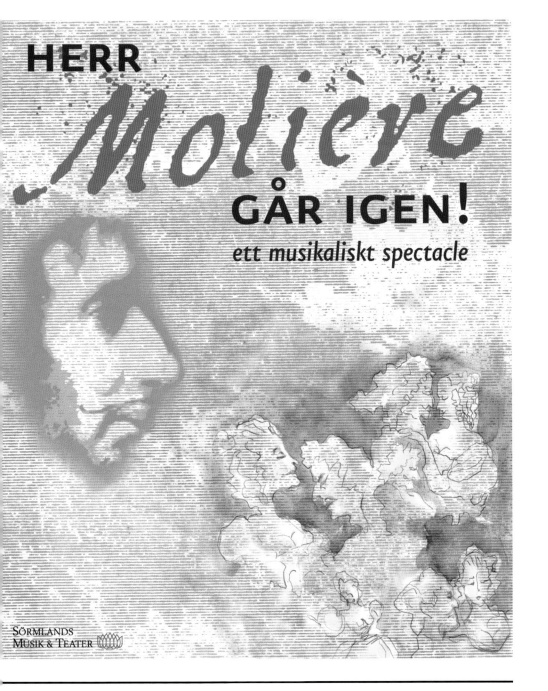

HERR *Molière* GÅR IGEN!
ett musikaliskt spectacle

SÖRMLANDS
MUSIK & TEATER

1 SOUP. VEGETABLES FOR WEB. SÖRMLANDS MATKLUSTER, 2006
2 "HERR MOLIERE GÅR IGEN". SÖRMLANDS MUSIK & TEATER, 2005

Jerker Eriksson

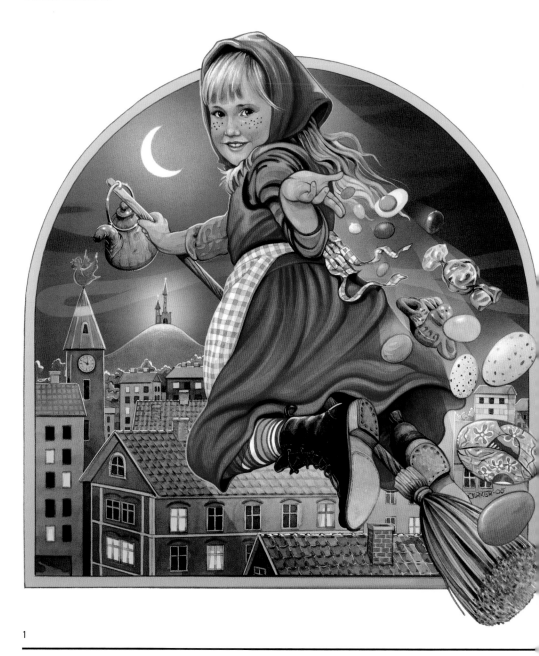

1

JERKER ERIKSSON AB **ADDRESS** FERSENS VÄG 9, SE-211 42 MALMÖ, SWEDEN
PHONE +46 (0)40 30 04 50, +46 (0)70 530 04 50 **E-MAIL** ILLUSTRATOR@JERKERERIKSSON.SE
WEBSITE WWW.JERKERERIKSSON.SE **CLIENTS** ADVERTISING AGENCIES, COMPANIES, PUBLISHERS

1 EASTER CANDY. KAKSERVICE/RHINO, 2005 2 RIDDERHEIMS/SHOUT, 2005

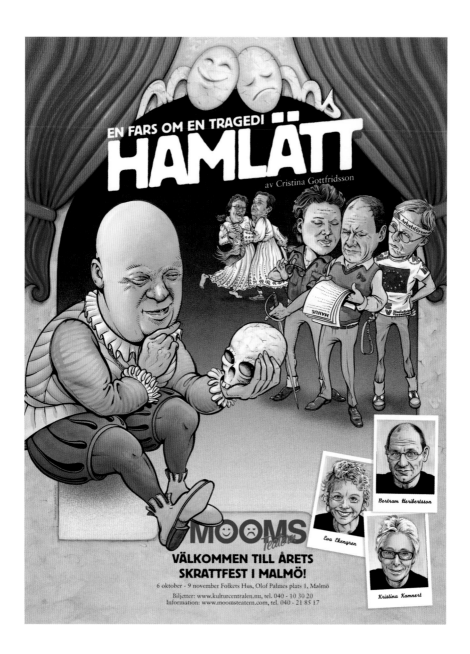

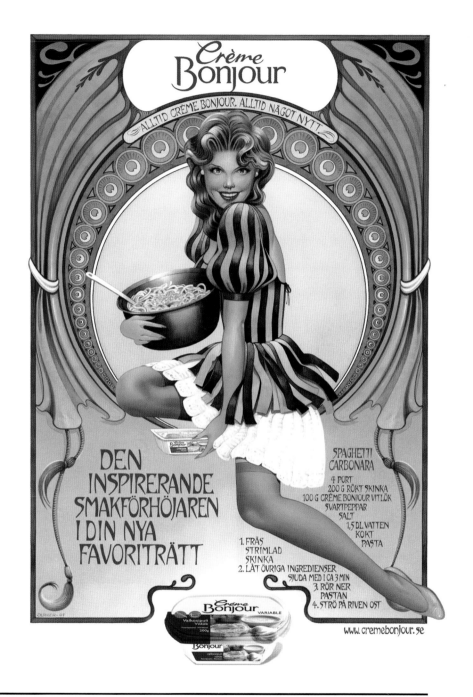

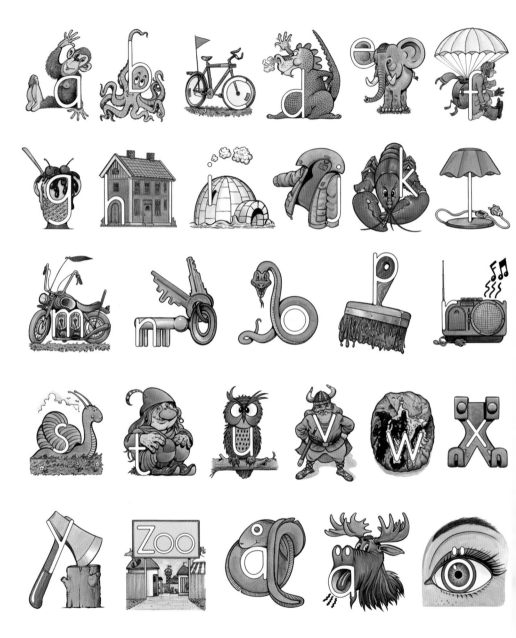

5 ALPHABET. ADASTRA FÖRLAG, 2006 **6–7** ALFA LAVAL. AHLQVIST & CO, 2007

Marianne Erlandsson

1

MARIANNE ERLANDSSON GRAFISK FORM **ADDRESS** FREGATTGATAN 11, SE-426 74 VÄSTRA FRÖLUNDA, SWEDEN
PHONE +46 (0)31 29 77 26, +46 (0)70 870 53 45 **E-MAIL** MARIANNE.ERLANDSSON@ILLUSTRATION.PP.SE
WEBSITE WWW.ILLUSTRATION.PP.SE **SPECIALITY** BOOK ILLUSTRATION, CHILDREN'S BOOKS, EDUCATIONAL MATERIAL
CLIENTS SCHOOLBOOK PUBLISHERS, ADVERTISING AGENCIES, SANTA MARIA, THE BOTANICAL GARDEN OF GOTHENBURG

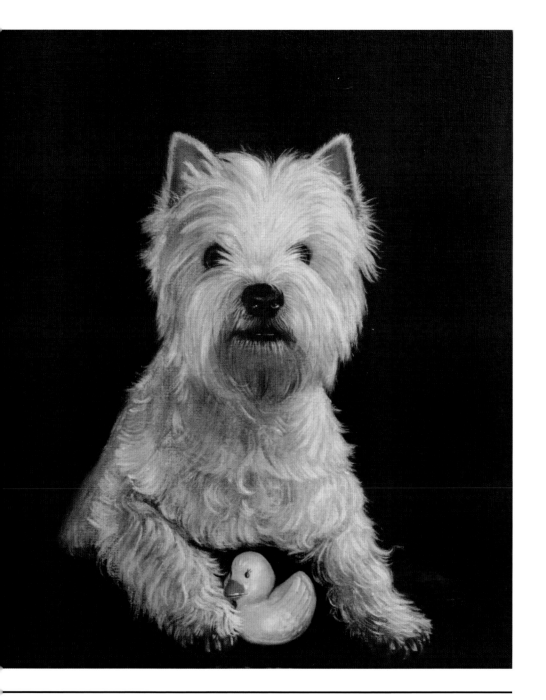

1 SPICE-JAR. WATERCOLOUR. SANTA MARIA, 1999 2 A WESTIE CALLED INEZ. OIL PAINTING. UNPUBLISHED, 2007

Lars Esselius

1

LARS ESSELIUS **ADDRESS** FOLKUNGAGATAN 98, SE-116 30 STOCKHOLM, SWEDEN
PHONE +46 (0)8 641 23 26 **E-MAIL** LARS.ESSELIUS@COMHEM.SE **WEBSITE** HTTP://WEB.COMHEM.SE/ESSELARS
SPECIALITY CONCEPTUAL DRAWING, MAGAZINE ILLUSTRATION **CLIENTS** JURE FÖRLAG, THE SWEDISH NATIONAL
COUNCIL FOR CRIME PREVENTION

1 CRIME BRINGS FEAR OF SHAME. ARTICLE ILLUSTRATION. BRÅ-PUBLICATION, 2005
2 HOLIDAY IN COACHMANIA. CD COVER FOR J.D KING. CT! JONATHAN THOMAS, 2007

Kid Falk

1

KID FALK **ADDRESS** LINNÉASTIGEN 1, SE-167 61 BROMMA, SWEDEN
PHONE +46 (0)70 769 34 25 **E-MAIL** KIDFALK@YAHOO.SE
SPECIALITY BOOK ILLUSTRATION, FASHION ILLUSTRATION, MAGAZINE ILLUSTRATION
CLIENTS REDPAGES, ARVONEN INTERNATIONAL, AXFOOD

Linn Fleisher

1

LINN FLEISHER **ADDRESS** BELLMANSGATAN 21, SE-118 47 STOCKHOLM, SWEDEN
PHONE +46 (0)70 491 34 32 **E-MAIL** LINN@LINNFLEISHER.SE **WEBSITE** WWW.LINNFLEISHER.SE
SPECIALITY BOOK COVERS, GRAPHIC DESIGN **CLIENTS** BOOK PUBLISHERS, MAGAZINES

2

1 CARTOON. OMVÅRDAREN, 2006 2 CHILDREN'S BOOK COVER. EN BOK FÖR ALLA, 2007

Krister Flodin

1

KRISTER FLODIN ILLUSTRATION **ADDRESS** TRANARÖVÄGEN 22, SE-134 64 INGARÖ, SWEDEN
PHONE +46 (0)8 744 46 39, +46 (0)70 847 52 44 **E-MAIL** KRISTER@FLODIN.BIZ **WEBSITE** WWW.FLODIN.BIZ
SPECIALITY ADVERTISING, ILLUSTRATING WEB PAGES AND MULTIMEDIA, MAGAZINE ILLUSTRATION
CLIENTS GEVALIA, MTV, 3, H.O.M.E MAGAZINE, RICHMOND PUBLISHING

1 HIT AND RUN ACCIDENTS. MAGAZINE ILLUSTRATION. VISÃO (PT), 2007
2 POSTER ART. POSTERLOUNGE.DE (DE), 2006

Ingrid Flygare

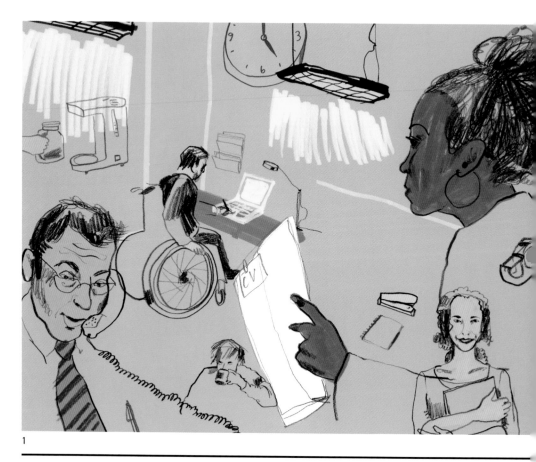

1

INGRID FLYGARE ILLUSTRATION **ADDRESS** C/O RITHUSET, ÅSÖGATAN 119, SE-116 24 STOCKHOLM, SWEDEN
PHONE +46 (0)8 20 12 00, +46 (0)70 731 39 82 **E-MAIL** IF@INGRIDFLYGARE.SE **WEBSITE** WWW.INGRIDFLYGARE.SE
SPECIALITY ADVERTISING, BOOK ILLUSTRATION, MAGAZINE ILLUSTRATION **CLIENTS** SVT, BONNIER UTBILDNING,
RABÉN & SJÖGREN, JOURNALISTGRUPPEN, DRAMATEN

3

1 WORKPLACE DIVERSITY. MAGAZINE ILLUSTRATION. THE DEVELOPMENT COUNCIL, 2006
2 DOGS BEHAVING BADLY. MAGAZINE ILLUSTRATION. HÄRLIGA HUND, 2006
3 HOME STAGING. MAGAZINE ILLUSTRATION. SKÖNA HEM, 2007

Per-Åke Forsgren

1

PER-ÅKE FORSGREN ILLUSTRATION & REKLAM **ADDRESS** LAVENDELVÄGEN 59, SE-702 18 ÖREBRO, SWEDEN
PHONE +46 (0)19 33 25 50 **E-MAIL** INFO@ILLUSTRATION-REKLAM.SE **WEBSITE** WWW.ILLUSTRATION-REKLAM.SE
SPECIALITY ADVERTISING, CARTOONS, COMICS

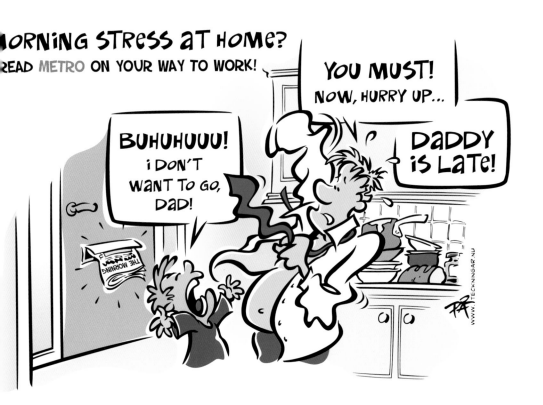

MORNING STRESS AT HOME?
READ METRO ON YOUR WAY TO WORK!

BUHUHUUU!
i DON'T
WANT TO GO,
DAD!

YOU MUST!
NOW, HURRY UP...

DADDY
iS LATE!

BUILDING SEPARATION

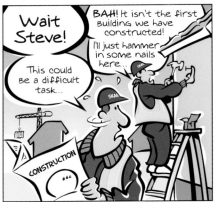

1 HALDEX. CAMPAIGN CHARACTER. A-BYRÅN/HALDEX GARPHYTTAN, 2005
2 MORNING STRESS. NEWSPAPER SALES PROMOTION. AB METRO, 2005
3 BUILDING SEPARATION. CARTOON FOR PRESENTATION. SKANSKA SVERIGE, 2006

Kersti Frid

1

KERSTI FRID GRAFISK FORMGIVNING **ADDRESS** NORRSKOGSVÄGEN 43, TORÖ, SE-149 92 NYNÄSHAMN, SWEDEN
PHONE +46 (0)520 315 65 **E-MAIL** FRID.HJORTH@TELIA.COM **WEBSITE** WWW.ILLUSTRATORCENTRUM.SE
SPECIALITY BOOK COVERS, BOOK ILLUSTRATION, MAGAZINE ILLUSTRATION

Ulf Frödin

1

FIRMA ULF FRÖDIN **ADDRESS** KATARINA BANGATA 19, SE-116 39 STOCKHOLM, SWEDEN
VISITING ST PAULSGATAN 13, STOCKHOLM **PHONE** +46 (0)8 641 43 25, +46 (0)70 483 29 02 **E-MAIL** ULF@FRODIN.INFO
WEBSITE WWW.FRODIN.INFO **SPECIALITY** BOOK COVERS, CARTOONS, CONCEPTUAL DRAWING **CLIENTS** DAGENS NYHETER,
RÅD & RÖN, THE SWEDISH DISABILITY OMBUDSMAN, ARBMANS:HANEBY

9 **1** CARTOON. DAGENS NYHETER, 2007 **2** SCETCH FOR BOOK COVER. OWN PROJECT, 2006

Thomas Fröhling

2

1

FRÖHLING PRODUKTION AB **ADDRESS** STOCKHOLM ILLUSTRATION, STORA NYGATAN 44, SE-111 27 STOCKHOLM, SWEDEN
PHONE +46 (0)8 22 22 03 **E-MAIL** THOMAS@STOCKHOLMILLUSTRATION.COM **WEBSITE** WWW.STOCKHOLMILLUSTRATION.COM
SPECIALITY ADVERTISING, EDUCATIONAL MATERIAL, MAGAZINE ILLUSTRATION **CLIENTS** H. ASCHEHOUG & CO, BOKFÖRLAGET
NATUR & KULTUR, LIBER, SIF

1

Karin Gandini

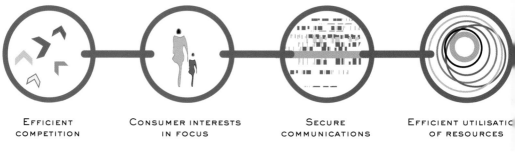

| EFFICIENT | CONSUMER INTERESTS | SECURE | EFFICIENT UTILISATIO |
| COMPETITION | IN FOCUS | COMMUNICATIONS | OF RESOURCES |

1

GANDINI FORMA **ADDRESS** HOLLÄNDARGATAN 8 B, SE-113 40 STOCKHOLM, SWEDEN
PHONE +46 (0)8 546 60 714, +46 (0)70 792 45 17 **E-MAIL** KARIN@GANDINIFORMA.NU **WEBSITE** WWW.GANDINIFORMA.NU
SPECIALITY GRAPHIC DESIGN, LOGOTYPES, CONCEPTUAL DRAWING **CLIENTS** BONNIER UTBILDNING, SWEDISH RED CROSS,
REGGIO EMILIA INSTITUTE, THE SWEDISH NATIONAL POST AND TELECOM AGENCY

about **cellular**

about **phonecard**

about **phone**

1 LOGOTYPE FOR PROJECT. THE SWEDISH NATIONAL POST AND TELECOM AGENCY, 2005
2 BROCHURE. THE SWEDISH NATIONAL POST AND TELECOM AGENCY, 2006

3

4

5

3 EXHIBITION MATERIAL. THE STOCKHOLM CRAFT AND SMALL BUSINESS ASSOCIATION, 2002
4 VIDEOFILM COVER. BONNIER UTBILDNING, 2004 **5** BOOK COVER. SWEDISH RED CROSS, 2001

Li Gessbo

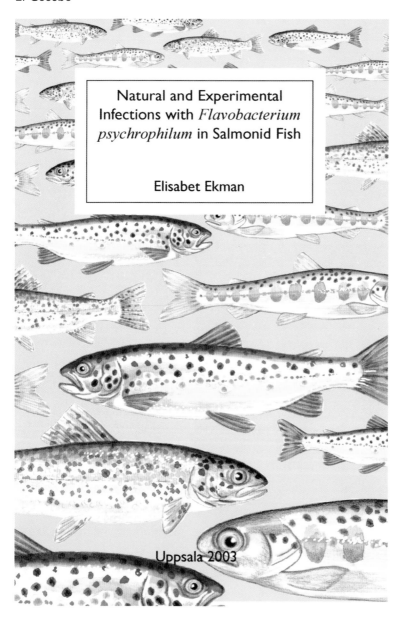

Natural and Experimental
Infections with *Flavobacterium
psychrophilum* in Salmonid Fish

Elisabet Ekman

Uppsala 2003

1

LI GESSBO ILLUSTRATION **ADDRESS** NATURSTENSVÄGEN 91, SE-752 68 UPPSALA, SWEDEN
PHONE +46 (0)18 55 04 29, +46 (0)73 728 05 15 **E-MAIL** INFO@GESSBO.COM **WEBSITE** WWW.GESSBO.COM
SPECIALITY CONCEPTUAL DRAWING, GRAPHIC DESIGN, EDUCATIONAL MATERIAL **CLIENTS** TIDNINGEN FOLKET,
THE MUNICIPALITY OF ESKILSTUNA, THE NATIONAL FORTIFICATIONS ADMINISTRATION, IF, DJURTANDVÅRDSKLINIKEN

Illustration och form: Li Gessbo

Lotta Glave

1

BENGT & LOTTA AB **ADDRESS** HOLLÄNDARGATAN 40, SE-113 59 STOCKHOLM, SWEDEN
PHONE +46 (0)8 660 65 15 **E-MAIL** LOTTA@BENGT-LOTTA.SE **WEBSITE** WWW.BENGT-LOTTA.SE
SPECIALITY BOOK ILLUSTRATION, EDUCATIONAL MATERIAL, MAGAZINE ILLUSTRATION
CLIENTS KLIPPANS YLLEFABRIK, STADSMISSIONEN, BOOKBINDERS DESIGN, GLEERUPS UTBILDNING, VÅRDFACKET

2

1 THE FIRST YOGA LESSON. OWN PROJECT **2** CHRISTMAS CARD. STADSMISSIONEN

Owe Gustafson

OWE GUSTAFSON **ADDRESS** LILL-JANS PLAN 2, SE-114 25 STOCKHOLM, SWEDEN
PHONE +46 (0)8 640 03 23, +46 (0)70 830 37 88 **E-MAIL** OWE.GUSTAFSON@COMHEM.SE
SPECIALITY BOOK COVERS, BOOK ILLUSTRATION, MAGAZINE ILLUSTRATION

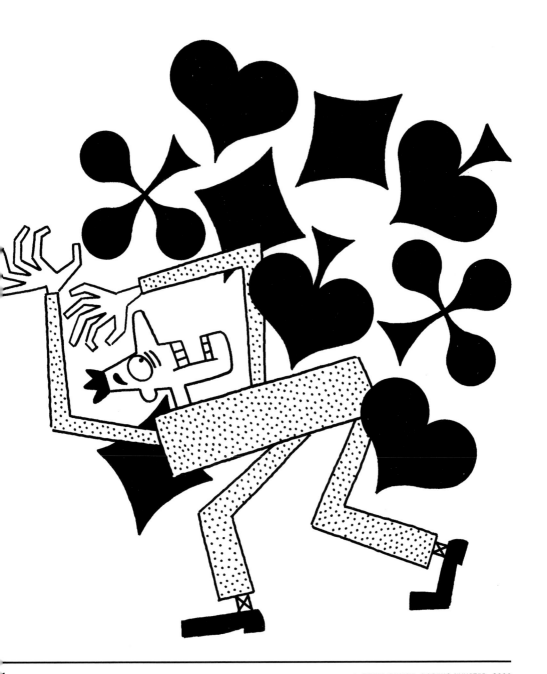

Åsa Gustafsson

1

ÅG ILLUSTRATION **ADDRESS** KÖPMANGATAN 4 B, SE-633 56 ESKILSTUNA, SWEDEN
PHONE +46 (0)16 51 48 48, +46 (0)73 048 96 46 **E-MAIL** INFO@ASAGUSTAFSSON.SE **WEBSITE** WWW.ASAGUSTAFSSON.SE
SPECIALITY CHILDREN'S BOOKS ILLUSTRATION, EDUCATIONAL MATERIAL, POSTCARDS AND POSTERS

2

3

1–2 MAGAZINE ILLUSTRATIONS. LEO & MAJKEN, 2006
3 "DATASPELET". BOOK FOR EARLY READERS. GLEERUPS UTBILDNING, 2007

Helena Halvarsson

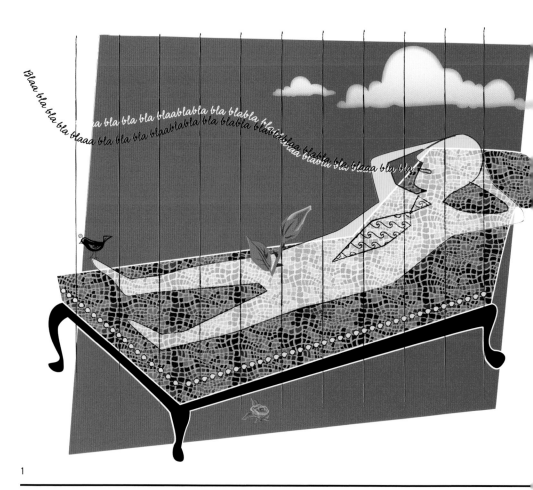

1

HH BILD **ADDRESS** TIMMERMANSGATAN 43, SE-118 55 STOCKHOLM, SWEDEN
PHONE +46 (0)8 694 80 70 **E-MAIL** HELENA@HHBILD.SE **WEBSITE** WWW.HHBILD.SE
SPECIALITY ADVERTISING, CONCEPTUAL DRAWING, MAGAZINE ILLUSTRATION
CLIENTS KAROLINSKA INSTITUTET, BANKGIROT, LIBER, METROTEKNIK, SIDA

1 PORTNOY'S COMPLAINT. AKADEMIKERN, 2007
2 MOVEMENT. OWN PROJECT, 2006

Annika Hansson

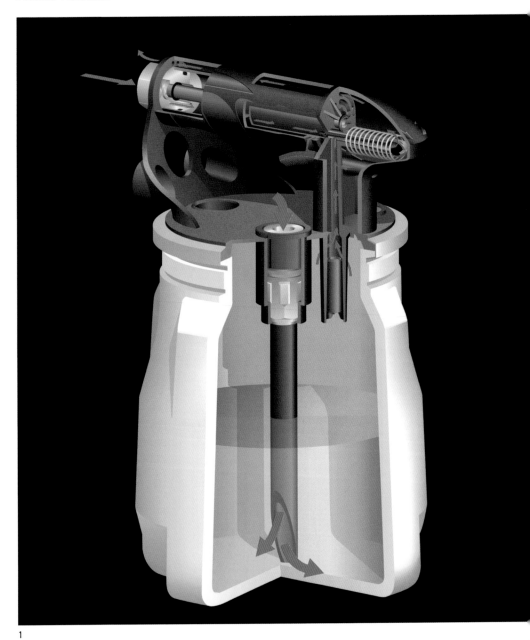

1

AH ILLUSTRATION KB **ADDRESS** NORRA GUBBEROGATAN 17, SE-416 63 GÖTEBORG, SWEDEN
PHONE+46 (0)73 975 47 63 **E-MAIL** ANNIKA@AHILLUSTRATION.SE **WEBSITE** WWW.AHILLUSTRATION.SE
SPECIALITY TECHNICAL ILLUSTRATION **CLIENTS** CEJN, SWEDISH ENERGY AGENCY, PATENTBYRÅN CEGUMARK

1 DRAINX. VACULA AUTOMOTIVE PRODUCTS. CEJN, 2006
2 ÅLÖ. VIGNETTE. CEJN, 2007 3 ENSO. VIGNETTE. CEJN, 2007

Riber Hansson

1

FIRMA RIBER **ADDRESS** GARVARGATAN 5, SE-112 21 STOCKHOLM, SWEDEN
PHONE +46 (0)8 650 88 84, +46 (0)73 650 88 84 **E-MAIL** RIBER@RIBER.NET **WEBSITE** WWW.RIBER.NET
SPECIALITY CARTOONS, MAGAZINE ILLUSTRATION, PORTRAITS **CLIENTS** SYDSVENSKA DAGBLADET, MAGASINET NEO,
INTERNAZIONALE (IT), COURRIER INTERNATIONAL (FR), LE MONDE (FR)

2

1 ARCHITECTURE. THEME ILLUSTRATION. MAGASINET NEO, 2007
2 FISHING QUOTAS. EDITORIAL CARTOON. COURRIER INTERNATIONAL (FR), 2005
3 BIN LADEN. EDITORIAL CARTOON. SYDSVENSKA DAGBLADET, 2006

Tove Hennix

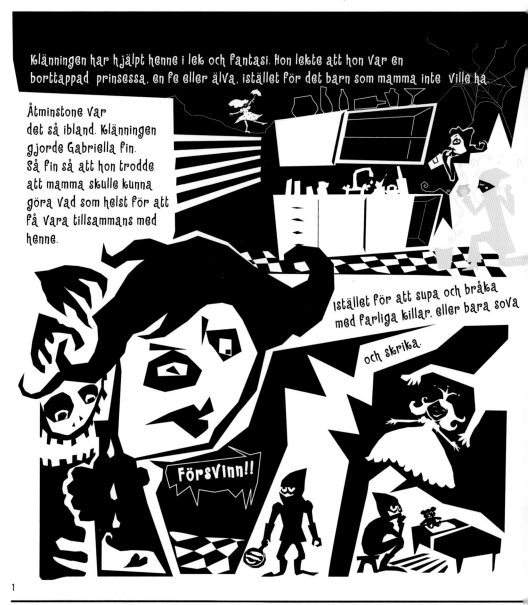

Klänningen har hjälpt henne i lek och fantasi. Hon lekte att hon var en borttappad prinsessa, en fe eller älva, istället för det barn som mamma inte ville ha.

Åtminstone var det så ibland. Klänningen gjorde Gabriella fin. Så fin så att hon trodde att mamma skulle kunna göra vad som helst för att få vara tillsammans med henne.

Istället för att supa och bråka med farliga killar, eller bara sova och skrika.

FörsVinn!!

1

TOVE HENNIX **ADDRESS** ST ERIKSPLAN 9, SE-113 20 STOCKHOLM, SWEDEN
PHONE +46 (0)70 888 95 77 **E-MAIL** TOVE@HEJFORM.COM **WEBSITE** WWW.HEJFORM.COM
SPECIALITY ADVERTISING, BOOK ILLUSTRATION, MAGAZINE ILLUSTRATION **CLIENTS** KREATIV INSIKT,
THE ENVIRONMENT AND HEALTH ADMINISTRATION OF STOCKHOLM, SAS, LIVING HISTORY FORUM, MARELD

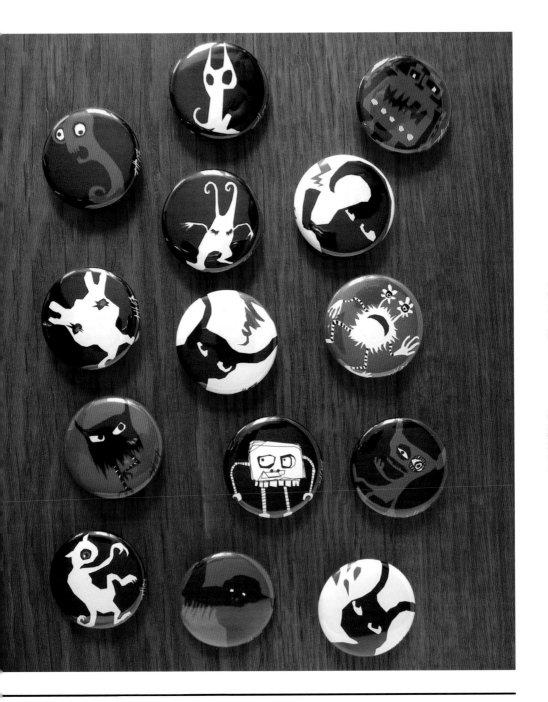

1

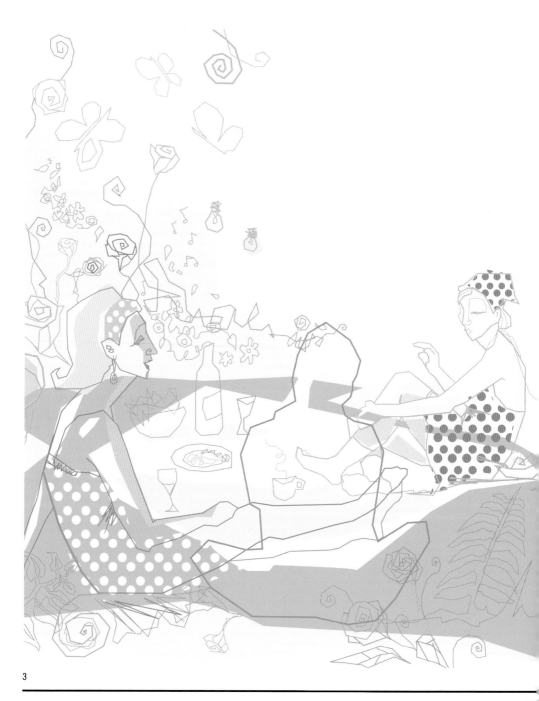

3

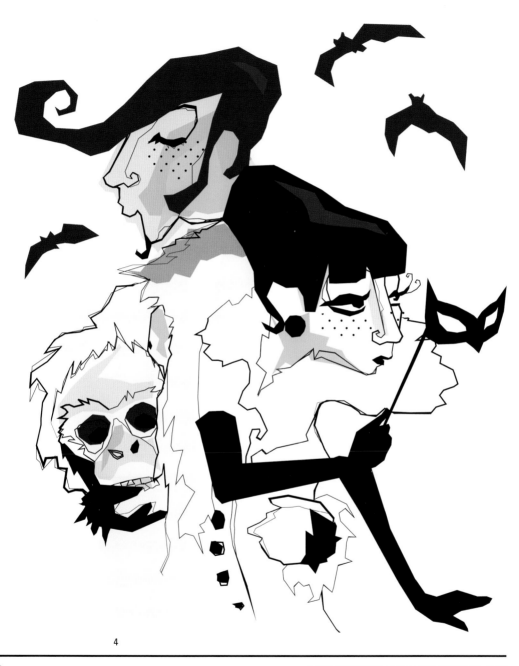

4

Sara Hernández

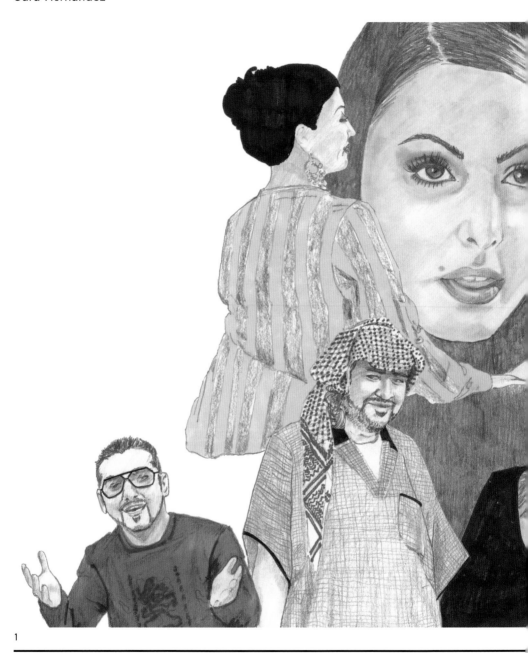

1

SARA HERNÁNDEZ **ADDRESS** OLA HANSSONSGATAN 3, SE-112 52 STOCKHOLM, SWEDEN **PHONE** +46 (0)73 358 24 76
VISITING BIRGER JARLSGATAN 18 A, STOCKHOLM **E-MAIL** SARA@HERNANDEZ.SE **WEBSITE** WWW.HERNANDEZ.SE
SPECIALITY FASHION ILLUSTRATION, GRAPHIC DESIGN, MAGAZINE ILLUSTRATION **CLIENTS** DAGENS NYHETER, SYNSAM,
IDA SJÖSTEDT, GRÖNA LUNDS TIVOLI, THE STOCKHOLM INTERNATIONAL FILM FESTIVAL

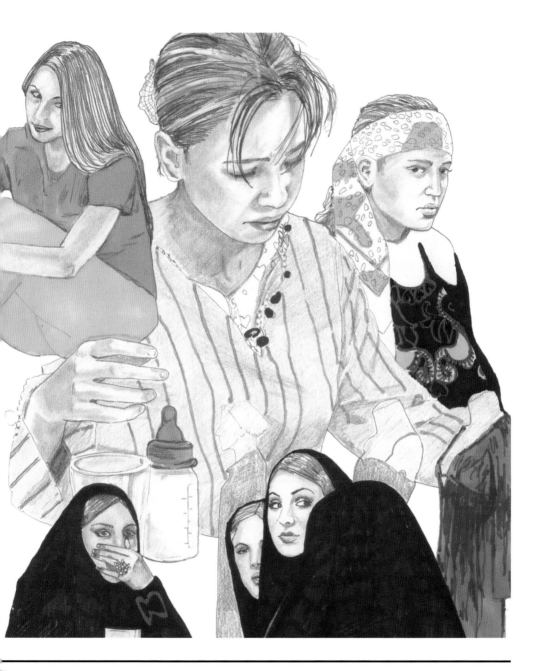

1 ARAB CINEMA IS BACK. CATALOGUE ILLUSTRATION. THE STOCKHOLM INTERNATIONAL FILM FESTIVAL, 2006

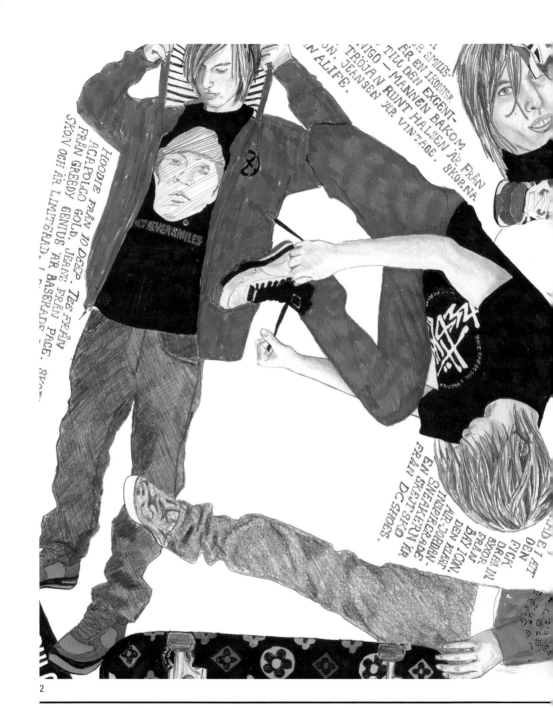

HOODIE FRÅN 10 DEEP. ACAPULGO GOLD. TEE FRÅN FRÅN GREEDY GENIUS 'AR LIMITERAD. I BASERADE PAGE. SKO...

...R SMILES. FÖR EN TROMMER FÖR DEN EXGENT- VIGO – MANNEN BAKOM TILL DEN EXGENT- ...ON. TRÖJAN RUNT HALSEN ÄR ...N. JEANSEN ÄR VINTAGE. SKORNA ...N ALIFE.

...ADE I ATT DEN PICK DRAG IN BXOR DEN KLART BAY ICON/ AIR-JORDAN- INSPIRERADE EN SNEAKER FRÅN SKEJTSKO FRÅN DC SHOES.

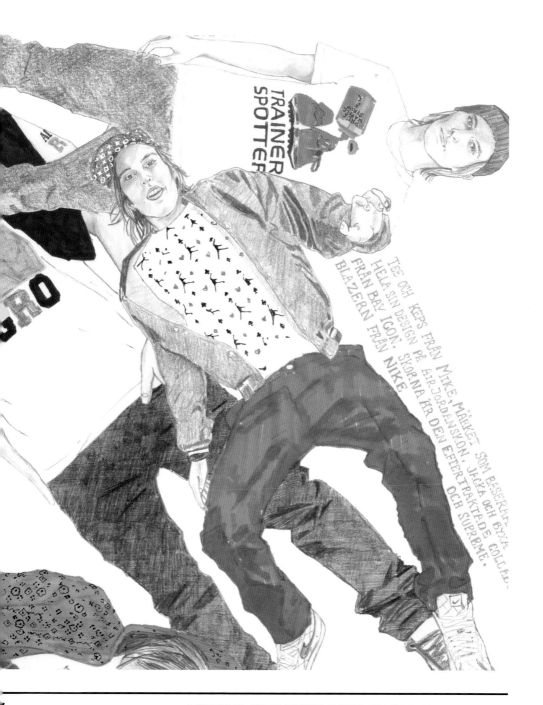

TEE OCH KEPS FRÅN MIKE. MÄRKET SOM BASERAT HELA SIN DESIGN PÅ AIR JORDENSKON. JACKA OCH BYXA FRÅN BAY ICON. SKORNA ÄR DEN EFTERTRAKTADE COLLPD BLAZERN FRÅN NIKE OCH SUPREME.

Cathrin Hesselstrand

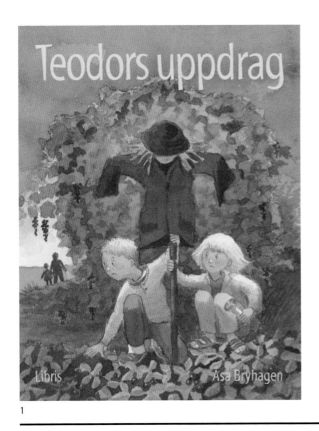

1

2

CATHRIN OCH JOHAN HESSELSTRAND **ADDRESS** JÄRNVÄGSGATAN 6, BOX 151, SE-592 23 VADSTENA, SWEDEN
PHONE +46 (0)143 128 60, +46 (0)70 225 06 45 **E-MAIL** CATHRIN@HESSELSTRAND.COM **WEBSITE** WWW.HESSELSTRAND.COM
SPECIALITY BOOK COVERS, BOOK ILLUSTRATION, CHILDREN'S BOOKS ILLUSTRATION **CLIENTS** BRAINBOOKS BOKFÖRLAG,
ARGUMENT FÖRLAG, LIBRIS FÖRLAG

3

9

1 "TEODORS UPPDRAG". CHILDREN'S BOOK. LIBRIS FÖRLAG, 2005
2 A CONTRACTOR. ILLUSTRATION FOR LIFE CYCLE COSTS. THE SWEDISH ASSOCIATION OF LOCAL
AUTHORITIES AND REGIONS/FORUM 1, 2007 **3** HOVSLAGAREGATAN IN VADSTENA. OWN PROJECT, 2006

Johan Hesselstrand

1

2

CATHRIN OCH JOHAN HESSELSTRAND **ADDRESS** JÄRNVÄGSGATAN 6, BOX 151, SE-592 23 VADSTENA, SWEDEN
PHONE +46 (0)143 128 60, +46 (0)70 225 06 45 **E-MAIL** JOHAN@HESSELSTRAND.COM **WEBSITE** WWW.HESSELSTRAND.COM
SPECIALITY CHILDREN'S BOOKS ILLUSTRATION, EDUCATIONAL MATERIAL, MAGAZINE ILLUSTRATION
CLIENTS BONNIER UTBILDNING, ARGUMENT FÖRLAG, LIBER, LIBRIS FÖRLAG, BOKFÖRLAGET NATUR & KULTUR

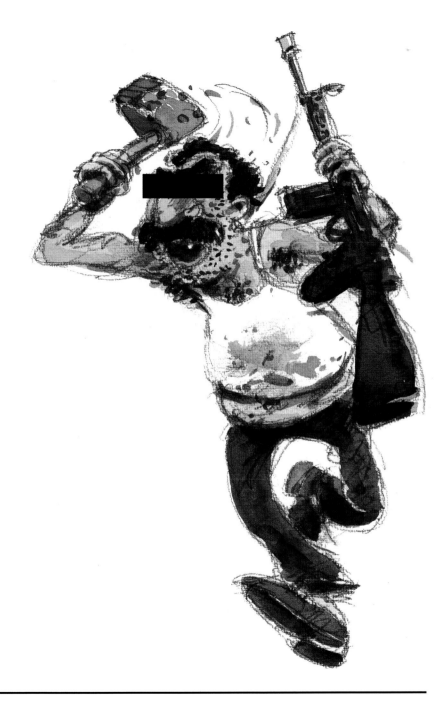

1 "CLOWNMYSTERIET". TEXTBOOK FOR AGE 9–10. BONNIER UTBILDNING, 2007
2 THE GRASS GROWS GREENER ON THE OTHER SIDE. DAGEN, 2006
3 HOW TO WRITE DAGO WITH INVISIBLE INK. JOURNALISTEN, 2005

Mia Hillerhag

I WANT TO BE YOUR DOG PRODUCTIONS **ADDRESS** ENTUNET 16, SE-181 48 LIDINGÖ, SWEDEN
PHONE +46 (0)8 767 07 16, +46 (0)70 748 37 47 **E-MAIL** MIA@HILLERHAG.SE **WEBSITE** WWW.HILLERHAG.SE
SPECIALITY COMICS, CONCEPTUAL DRAWING, MAGAZINE ILLUSTRATION **CLIENTS** LOOP MAGAZINE, STOCKHOLMSHEM,
THE NATIONAL INSTITUTE OF PUBLIC HEALTH IN SWEDEN, MIO, VÅR BOSTAD

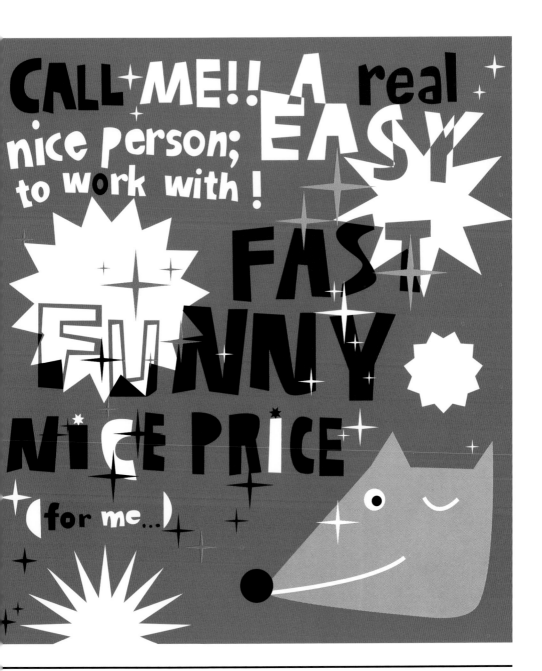

CALL ME!! A real nice person; EASY to work with ! FAST FUNNY NICE PRICE (for me...)

1 GENDER EQUALITY IN THE PUBLIC SECTOR. MAGAZINE ILLUSTRATION. LOOP, 2006 2 OWN PROJECT, 2007

Daniel Holking

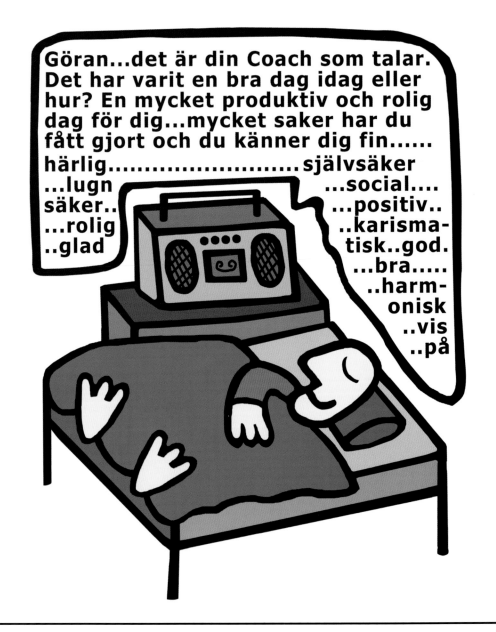

1

DANIEL HOLKING NEW MEDIA (DHNM) **ADDRESS** GRIMSTAGATAN 147, 2 TR, SE-162 58 VÄLLINGBY, SWEDEN
PHONE +46 (0)8 579 718 23, +46 (0)70 783 89 72 **E-MAIL** DANIEL@CARPE.NU **WEBSITE** WWW.CARPE.NU
SPECIALITY BOOK ILLUSTRATION, EDUCATIONAL MATERIAL, MAGAZINE ILLUSTRATION **CLIENTS** SOLNA STAD, CARLSBERG,
TELIASONERA, SOCIONOMEN, PM

1 GÖRAN THE SLEEPY. DU & JOBBET, 2004 2 CALENDAR ILLUSTRATION. SOLNA STAD, 2005
3 A COMPUTER CHIP WILL TRACK YOUR EVERY MOVE. UNPUBLISHED

4

5

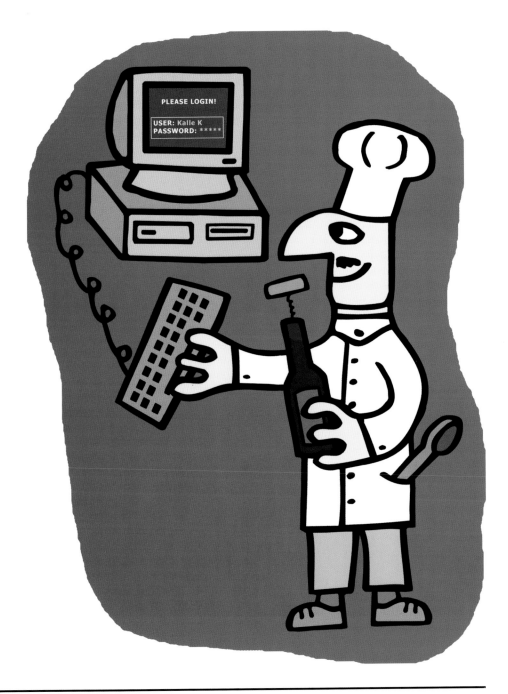

The text inside the illustration reads:

PLEASE LOGIN!

USER: Kalle K
PASSWORD: *****

4 HOW ABOUT A NICE SOAK IN THE BATH? UNPUBLISHED
5 WHAT IF YOUR EMPLOYMENT INTERVIEW WAS LIKE "IDOL"? DU & JOBBET, 2005
6 I FIND MY RECIPES ONLINE. C-AKTUELLT, CARLSBERG, 2004

Linda Holmer

1

FISK FORM **ADDRESS** ANDERS ZORNSGATAN 34 C, SE-412 72 GÖTEBORG, SWEDEN **PHONE** +46 (0)31 20 58 71,
+46 (0)70 833 63 98 **E-MAIL** LINDAHOLMER@FISKFORM.COM **WEBSITE** WWW.FISKFORM.COM **SPECIALITY** ADVERTISING,
EDUCATIONAL MATERIAL, MAGAZINE ILLUSTRATION **CLIENTS** VGR THE ENVIRONMENTAL COMMITTEE, CAPPELENS FORLAG,
MINISTRY OF EDUCATION AND RESEARCH (NO), SWEDISH STANDARDS INSTITUTE, GYLDENDAL FORLAG

Ulrica Hydman Vallien

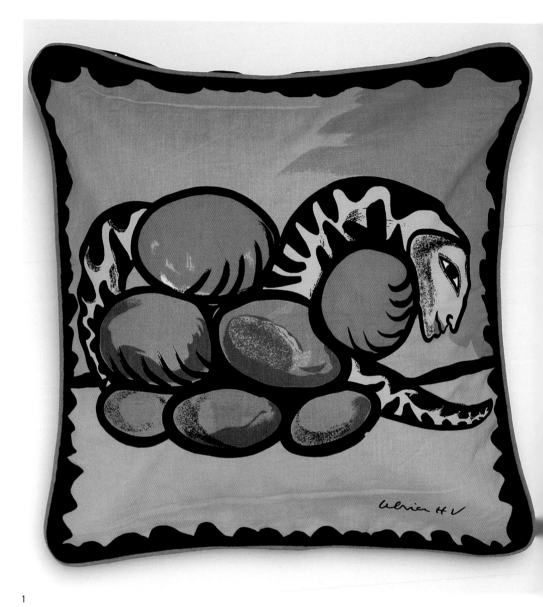

1

KOSTA BODA AB **ADDRESS** BROMS VÄG 8, SE-361 94 ERIKSMÅLA, SWEDEN **PHONE** +46 (0)471 411 81, +46 (0)70 557 31 45
E-MAIL ULRICAHV@UHV.SE **WEBSITE** WWW.ULRICAHYDMANVALLIEN.COM, WWW.UHV.SE **SPECIALITY** CHILDREN'S BOOKS
ILLUSTRATION, GRAPHIC DESIGN, POSTCARDS & POSTERS **CLIENTS** BOKFÖRLAGET NATUR & KULTUR, RABÉN & SJÖGREN,
CREA (JP), GRAPHIC TRAFFIC (JP)

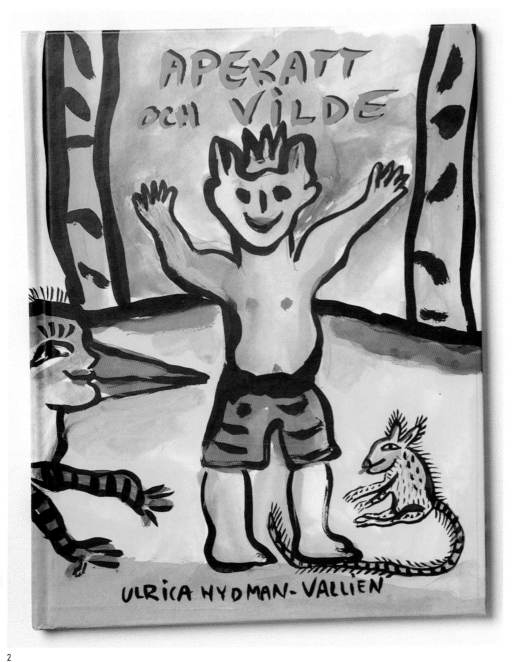

1 THE SNAKE'S EGGS. KINNASAND GMBH (DE), 1997
2 "APEKATT OCH VILDE". BOOK. COVER, TEXT AND ILLUSTRATION. RABÉN & SJÖGREN, 1996

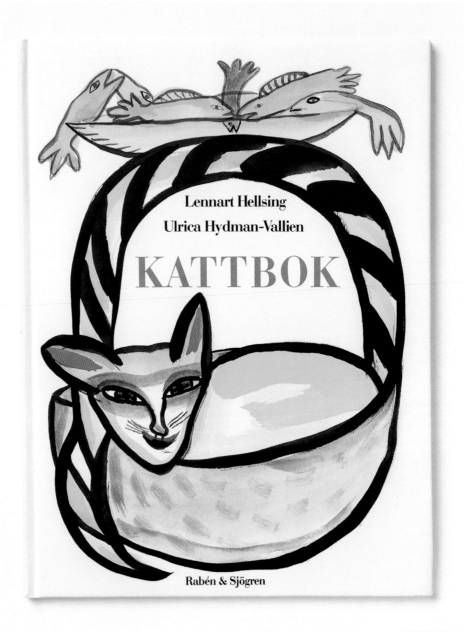

Lennart Hellsing

Ulrica Hydman-Vallien

KATTBOK

Rabén & Sjögren

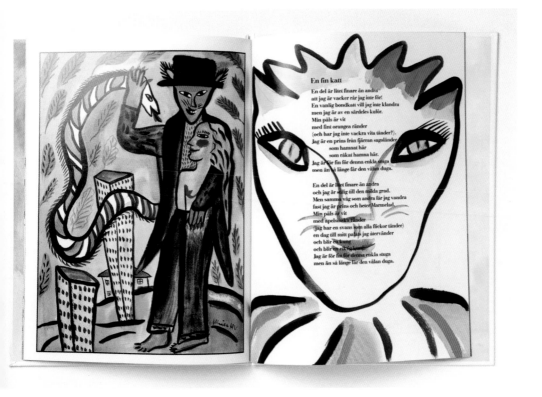

En fin katt

En del är litet finare än andra
att jag är vacker rår jag inte för!
En vanlig bondkatt vill jag inte klandra
men jag är av en särdeles kulör.
Min päls är vit
med fint orangea ränder
(och har jag inte vackra vita tänder?).
Jag är en prins från fjärran sagoländer
 som hamnat här
 som råkat hamna här.
Jag är för fin för denna enkla stuga
men än så länge får den vålan duga.

En del är litet finare än andra
och jag är säljg till den milda grad.
Men samma väg som andra får jag vandra
fast jag är prins och heter Marmelad.
Min päls är vit
med apelsinska tänder
(jag har en svans som alla flickor tänder)
en dag till mitt palats jag återvänder
och blir en kung
och blir en riktig kung.
Jag är för fin för denna enkla stuga
men än så länge får den vålan duga.

3–4 "KATTBOK". BOOK. COVER AND ILLUSTRATIONS. RABÉN & SJÖGREN, 1993

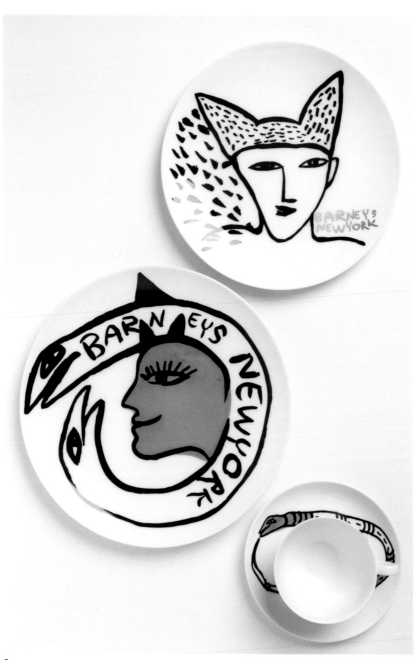

6

5 BARNEYS NEW YORK. ULRICA HYDMAN VALLIEN CHINAWARE/GRAPHIC TRAFFIC (JP), 2005
6 HE AND SHE. ALSTERMO BRUK/ESSELTE, 2005

Airi Iliste

1

ILLUSTRA ILISTE **ADDRESS** HORNSGATAN 116, SE-117 26, STOCKHOLM, SWEDEN
PHONE +46 (0)8 586 495 95, +46 (0)76 872 21 62 **E-MAIL** A@AIRI.SE **WEBSITE** WWW.AIRI.SE
SPECIALITY CONCEPTUAL DRAWING, FACTUAL GRAPHICS, GRAPHIC DESIGN
CLIENTS FORSKNING OCH FRAMSTEG, BOKFÖRLAGET NATUR & KULTUR, MONTELL POWERNEWS

1 "ENERGI – MÖJLIGHETER OCH DILEMMAN". THE ROYAL SWEDISH ACADEMY OF SCIENCES, 2007
2 "ENERGI – FRAMTIDSVISIONER". THE ROYAL SWEDISH ACADEMY OF SCIENCES, 2007

Sandra Isaksson

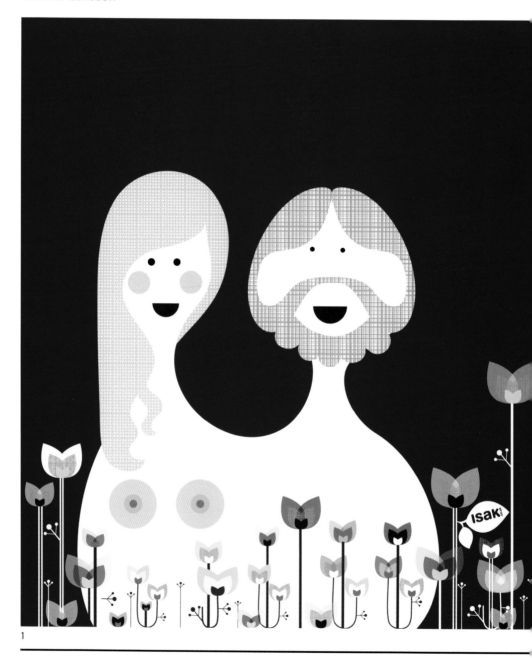

1

SANDRA ISAKSSON GRAPHIC DESIGN & ILLUSTRATION **ADDRESS** 9 WOODVIEW, ARUNDEL, WEST SUSSEX, BN18 9ED, UK
PHONE +44 (0)785 476 03 65 **E-MAIL** SANDRA@SANDRAISAKSSON.COM **WEBSITE** WWW.SANDRAISAKSSON.COM
SPECIALITY BOOK COVERS, BOOK ILLUSTRATION, GRAPHIC DESIGN **CLIENTS** WAITROSE, ALBERT BONNIERS FÖRLAG,
BOKFÖRLAGET PRISMA, ORANGE, VOLKSWAGEN

1 BLOSSOM & BILL TRAY. ILLUSTRATION FOR A SERIES OF HOMEWARE PRODUCTS. ISAK, 2006
2 TULIP WALLPAPER. PATTERN DESIGN FOR WALLPAPER AND A HOME ACCESSORIES RANGE. ISAK, 2006

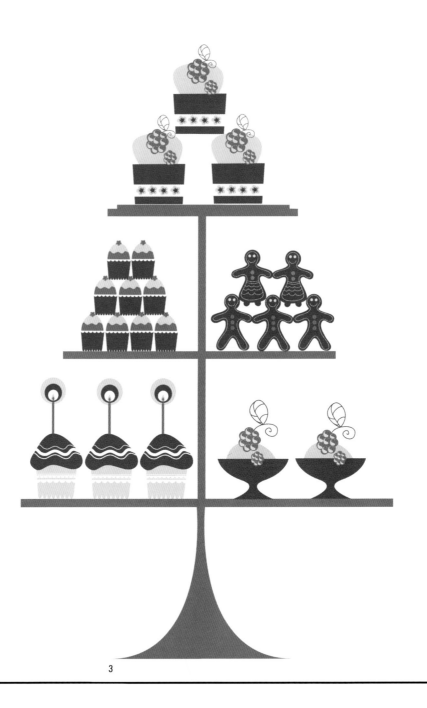

3

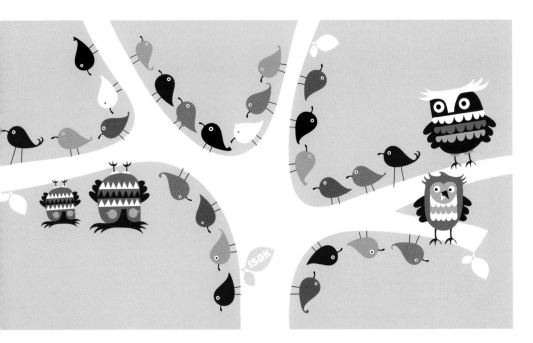

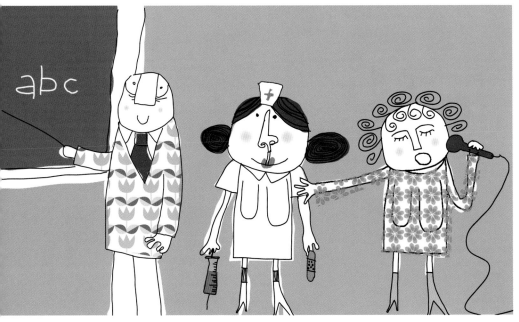

3 CAKE STAND. ILLUSTRATION AND PACKAGE DEVELOPMENT. WAITROSE PATISSERIE, WAITROSE, 2007
4 BIRDS AND OWLS. EDUCATIONAL POSTERS FOR CHILDREN. ISAK, 2007
5 PEOPLE. EDUCATIONAL POSTERS FOR CHILDREN. ISAK, 2007

Erica Jacobson

1

ERICA JACOBSON DESIGN **ADDRESS** KOCKSGATAN 24, SE-116 24 STOCKHOLM, SWEDEN
PHONE +46 (0)8 640 09 97, +46 (0)70 771 22 92 **E-MAIL** ERICA@ERICAJACOBSON.COM
WEBSITE WWW.ERICAJACOBSON.COM **SPECIALITY** ADVERTISING, MAGAZINE ILLUSTRATION, POSTERS
CLIENTS SVENSKA DAGBLADET, SAVE THE CHILDREN, THE ANNA LINDH MEMORIAL FUND, THE STOCKHOLM CITY THEATRE

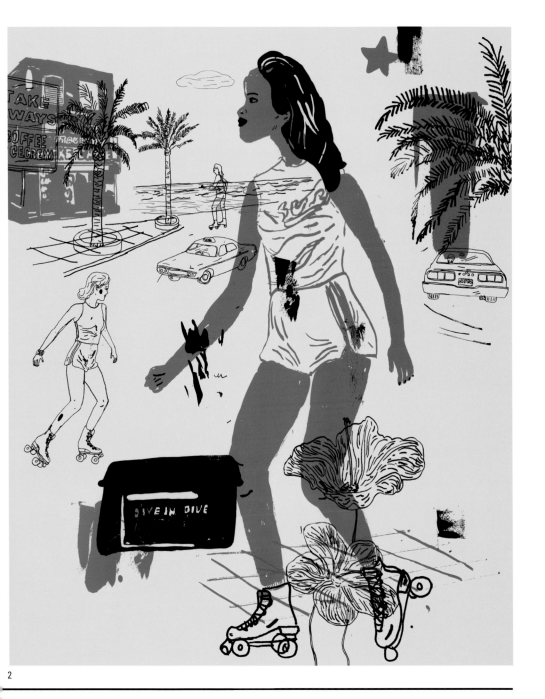

1 COVER FOR ART EXHIBITION PROGRAMME. ESKILSTUNA MUSEUM OF ART, 2007
2 ROLLER GIRL. SCREENPRINT. OWN PROJECT FOR ART EXHIBITION, 2006

Pål Jansson

1

PÅL PRODUKTION AB **ADDRESS** BÖLEN 112, SE-880 51 ROSSÖN, SWEDEN
PHONE +46 (0)624 200 38, +46 (0)70 659 29 33 **E-MAIL** PAAL@PAAL.SE **WEBSITE** WWW.PAAL.SE
SPECIALITY ADVERTISING, LOGOTYPES, STORYBOARDS **CLIENTS** LOWE BRINDFORS, EMBRINK, PIRATFÖRLAGET,
EWC SCANDINAVIA, MÄHLERS

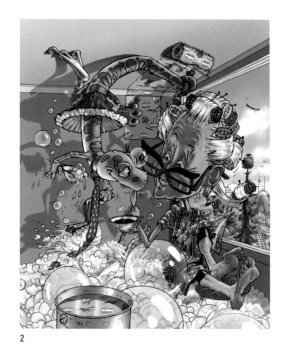

2

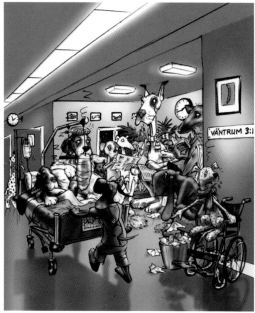

3

1 SAAB. SKETCH FOR ADVERTISEMENT. LOWE BRINDFORS, 2006
2 "TANTEN OCH ÖDLAN". CHILDREN'S BOOK. PIRATFÖRLAGET, 2007
3 "LARS OCH URBAN". CHILDREN'S BOOK. PIRATFÖRLAGET, 2005

Aleksandra Jarosz Laszlo

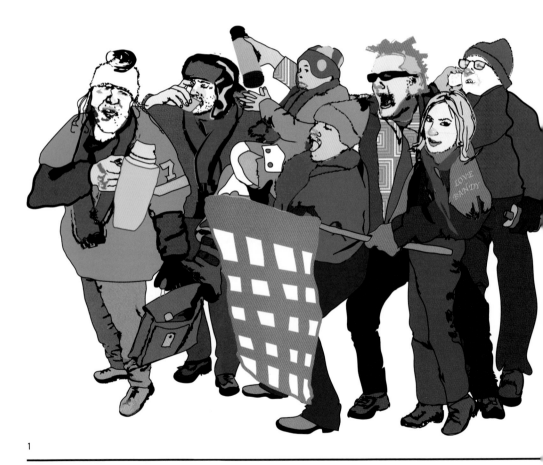

1

JAROSZ & LASZLO **ADDRESS** HOTELLBACKEN 2, SE-793 30 LEKSAND, SWEDEN **PHONE** +46 (0)73 038 56 88
E-MAIL ALEKSANDRA.JAROSZ@TELIA.COM **WEBSITE** WWW.JAROSZ-LASZLO.SE, WWW.PICTUREIT.NU
SPECIALITY BOOK ILLUSTRATION, GRAPHIC DESIGN, SUPPLYING BOTH ILLUSTRATION AND TEXT
CLIENTS CAP & DESIGN, CITY OF STOCKHOLM, SKÅDEBANAN DALARNA, AUTOWASH EXPRESS, MIXTRUM

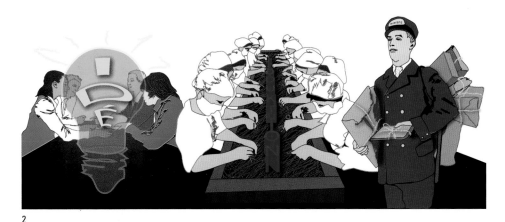

2

3

1 THE STAND. CAP & DESIGN, 2006 2 PRODUCTION. SELF PROMOTION, 2007
3 HULTSFRED 2007. SELF PROMOTION, 2006

Birgit Johannesson

1

BIRGIT JOHANNESSON **ADDRESS** MALMA RINGVÄG 2, SE-756 45 UPPSALA, SWEDEN
PHONE +46 (0)18 30 93 76, +46 (0)70 918 36 54 **E-MAIL** BIRGIT@BIRGITJOHANNESSON.SE
WEBSITE WWW.BIRGITJOHANNESSON.SE **SPECIALITY** BOOK COVERS, BOOK ILLUSTRATION, MAGAZINE ILLUSTRATION

2

Magnus Jonason

1

2

MAGNUS JONASON PRODUKTION AB **ADDRESS** HÖGALIDSGATAN 35, BOX 9203, SE-102 73 STOCKHOLM, SWEDEN
PHONE +46 (0)8 669 01 21, +46 (0)70 887 14 25 **E-MAIL** LANGEMANGE@EBREVET.NU **WEBSITE** WWW.LANGEMANGE.SE
SPECIALITY ADVERTISING, COMICS, PORTRAITS **CLIENTS** LOWE BRINDFORS, KING, WATERSWIDGREN, ÅKESTEM.HOLST,
SCHOLZ & FRIENDS

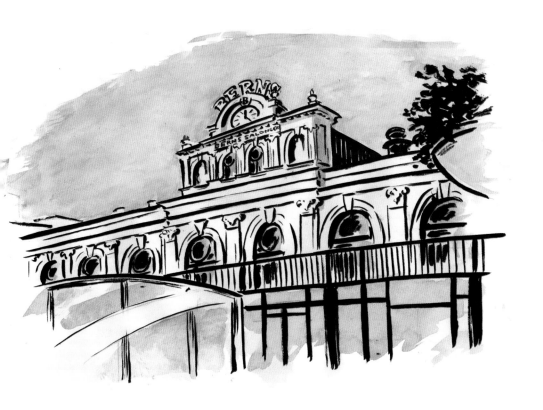

1 ADVERTISEMENT. BERNS RESTAURANT, 2005 **2** ADVERTISEMENT. BERNS HOTEL, 2005 **3** ADVERTISEMENT. BERNS, 2005

4

5

4 ADVERTISEMENT. BERNS RESTAURANT, 2005
5 ADVERTISEMENT. BERNS BAR, 2005 6 ADVERTISEMENT. BERNS RESTAURANT, 2005

7–8 ADVERTISEMENTS. BERNS CONFERENCE, 2005 **9** ADVERTISEMENT. BERNS BAR, 2005

Ingela Jondell

1

INGELA JONDELL ILLUSTRATION **ADDRESS** SICKLA KANALGATA 31, SE-120 76 STOCKHOLM, SWEDEN
PHONE +46 (0)8 751 14 02, +46 (0)73 430 65 02 **E-MAIL** INGELA.JONDELL@TELIA.COM **WEBSITE** WWW.INGELAJONDELL.SE
SPECIALITY FACTUAL GRAPHICS, EDUCATIONAL MATERIAL, MAGAZINE ILLUSTRATION **CLIENTS** ITWORKS SOFTWARE,
SWEDISH FOREST AGENCY, NATIONALNYCKELN, MNM MEDIA, FORMA PUBLISHING GROUP

19

1 SECURITY IN MY STORE. MAGAZINE ILLUSTRATION. SUPERMARKET/FORMA PUBLISHING GROUP, 2005
2 FLY. NATIONALNYCKELN, 2006 3 NOBLEMAN AND PRIEST. FILM ILLUSTRATION. MNM MEDIA, 2007

Åsa Jägergård

1

ÅSAS FIRMA – GRAFISK FORM OCH ILLUSTRATION **ADDRESS** FÖRSTA PARKGATAN 3, SE-824 43 HUDIKSVALL, SWEDEN
PHONE +46 (0)650 133 14 **E-MAIL** ASA@ASASFIRMA.SE **WEBSITE** WWW.ASASFIRMA.SE
SPECIALITY BOOK COVERS, GRAPHIC DESIGN, LOGOTYPES **CLIENTS** BOKFÖRLAGET NATUR & KULTUR, IGGESUND
PAPERBOARD, HÄLSINGLANDS MUSEUM, FORSA FOLKHÖGSKOLA, THE COUNTY ADMINISTRATIVE BOARD OF GÄVLEBORG

FREINETGYMNASIET I LJUSDAL

1 SYMBOLS FOR WEBSITE. CITY OF HUDIKSVALL, 2006
2 COVER FOR INFORMATION FOLDER. FREINETGYMNASIET LJUSDAL, 2006

Per José Karlén

1

PERPICTURES.COM **ADDRESS** ESTERSVÄGEN 5, SE-793 33 LEKSAND, SWEDEN
PHONE +46 (0)247 349 15, +44 (0)79 440 873 61 **E-MAIL** PER.KARLEN@PERPICTURES.COM
WEBSITE WWW.PERPICTURES.COM **SPECIALITY** ADVERTISING, SUPPLYING BOTH ILLUSTRATION AND TEXT,
BOOK ILLUSTRATION **CLIENTS** IBM, SWATCH, RABÉN & SJÖGREN, CGI BRANDSENSE, ORANGE PHONE

2

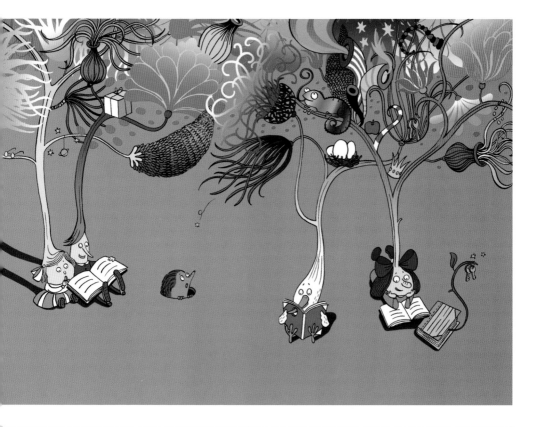

1 POSTER. NHS LONDON, 2007 2 ANIMATED WEB BANNER. ORANGE PHONE, 2007
3 CATALOGUE COVER. RABÉN & SJÖGREN, 2006

Kenneth Karlsson

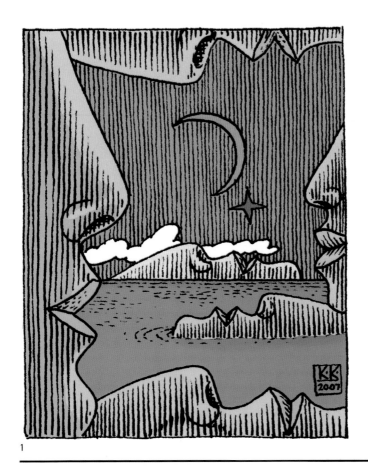

1

BLÅ ELEFANT ILLUSTRATION **PHONE** +46 (0)70 661 80 21 **E-MAIL** KENNETH@ELEFANTEN.SE **WEBSITE** WWW.ELEFANTEN.SE
SPECIALITY CONCEPTUAL DRAWING, MAGAZINE ILLUSTRATION, POSTCARDS AND POSTERS

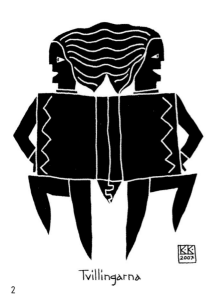

Tvillingarna

2

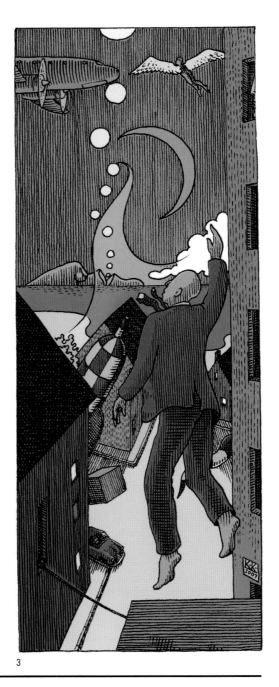

3

Katy Kimbell

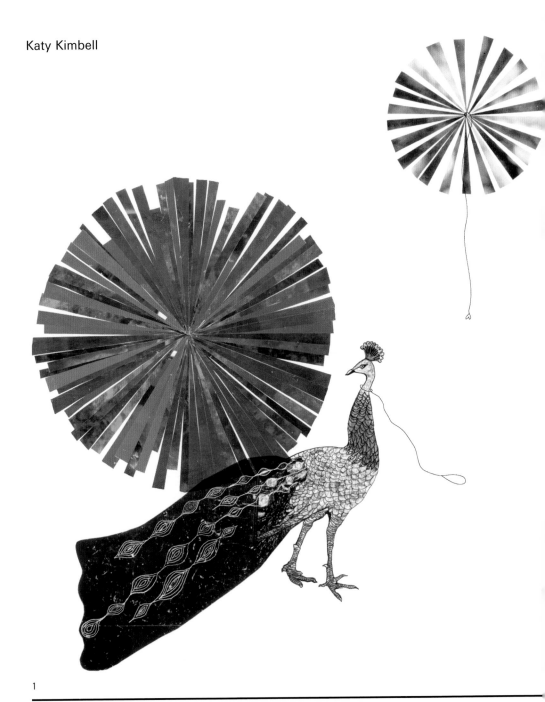

1

KATY KIMBELL, GRAFISK DESIGN & ILLUSTRATION **ADDRESS** ERSTAGATAN 32-34, SE-116 36 STOCKHOLM, SWEDEN
PHONE +46 (0)8 642 13 74, +46 (0)70 686 13 74 **E-MAIL** MAIL@KATYKIMBELL.NU **WEBSITE** WWW.KATYKIMBELL.NU
SPECIALITY BOOK COVERS, GRAPHIC DESIGN, MAGAZINE ILLUSTRATION **CLIENTS** BOKFÖRLAGET NATUR & KULTUR,
BOKFÖRLAGET PRISMA, NORMAL FÖRLAG, CHOKLADFABRIKEN, FOOD AND FRIENDS

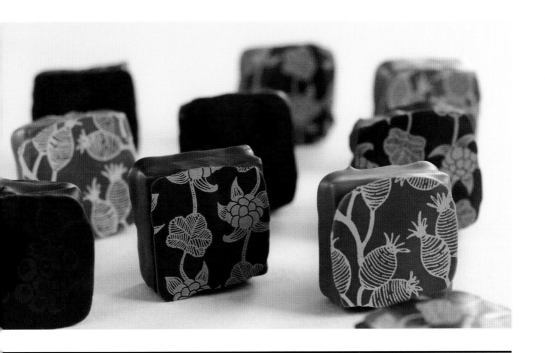

1 PEACOCK. CALENDAR. LIKA PRESS, 2006 2 CHOKLADFABRIKEN, 2006
3 ILLUSTRATED CHOCOLATE CREAM DECORATION. PHOTOGRAPHY BY SARA DANIELSSON. CHOKLADFABRIKEN, 2006

4 FOOD ILLUSTRATION. ARLA/FOOD AND FRIENDS, 2006
5 INVITATION. MARIELLE KERBER, 2005 **6** COOKBOOK. BOKFÖRLAGET PRISMA, 2007

Kerold Klang

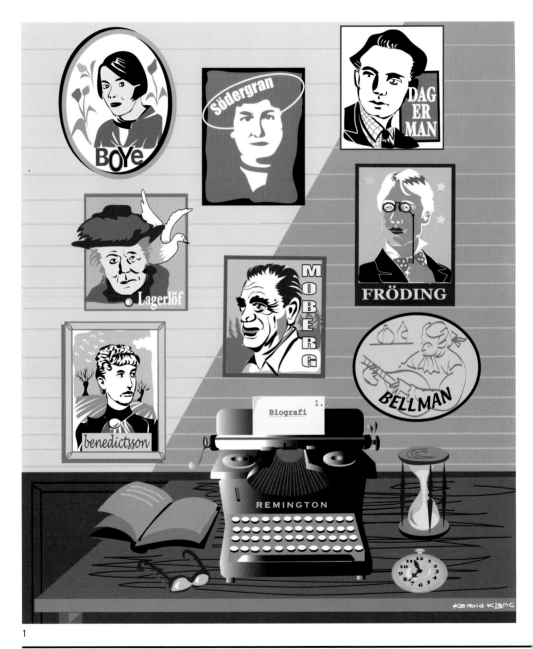

1

CITAT JOURNALISTGRUPPEN **ADDRESS** STRANDBERGSGATAN 20, BOX 30 159, SE-104 25 STOCKHOLM, SWEDEN
PHONE +46 (0)8 610 20 14 **E-MAIL** KEROLD.KLANG@CITAT.SE **WEBSITE** WWW.CITAT.SE
SPECIALITY COMICS, ILLUSTRATING WEB PAGES AND MULTIMEDIA, MAGAZINE ILLUSTRATION
CLIENTS ROYAL INSTITUTE OF TECHNOLOGY, TRYGG-HANSA, SVERIGES RIKSBANK, SEB, BARNCANCERFONDEN

3

1 CROSS-SECTION. MAGAZINE ILLUSTRATION. THE SWEDISH RESEARCH COUNCIL, 2005
2 NEWSPAPER COMIC STRIP. SVENSKA DAGBLADET, 2001 3 YEARBOOK 2004. THE SWEDISH RESEARCH COUNCIL, 2004

kerold klang 2005

4 MAGAZINE ILLUSTRATION. BARN & CANCER/BARNCANCERFONDEN, 2006 **5** POSTER, 2005

Magda Korotynska

1

MAGDAS FÄRGPENNA **ADDRESS** DREJARGATAN 1 A, SE-113 42 STOCKHOLM, SWEDEN
PHONE +46 (0)8 30 66 23, +46 (0)73 332 55 86 **E-MAIL** MAGDA.K@SWIPNET.SE
SPECIALITY BOOK ILLUSTRATION, LOGOTYPES, MAGAZINE ILLUSTRATION

2

3

1 NATIONALNYCKELN, 2006 2 SELF PROMOTION, 2005
3 CALENDAR ILLUSTRATION. SOCIALDEMOKRATISKA KOMBILOTTERIET, 2006

Ladislav Kosa

1

MR KOSA **ADDRESS** KORNETTSGATAN 22 A, SE-211 50 MALMÖ, SWEDEN **VISITING** NORRA NEPTUNIGATAN 25, MALMÖ
PHONE +46 (0)76 250 15 88 **E-MAIL** INFO@MRKOSA.COM **WEBSITE** WWW.MRKOSA.COM
SPECIALITY GRAPHIC DESIGN, MAGAZINE ILLUSTRATION, POSTCARDS AND POSTERS
CLIENTS SYDSVENSKA DAGBLADET, ICA, WAHLSTRÖM & WIDSTRAND, TAMBOURINE STUDIOS, HEPP FILM

2

3

1 TELEVISION IN THE NEW DIGITAL AGE. MAGAZINE ILLUSTRATION. KOMET/APPELBERG MAGAZINE FÖRLAG, 2007
2 LAWS AND REGULATIONS WHEN PLAYING GOLF ABROAD. MAGAZINE ILLUSTRATION. GOLFRESAN, 2006
3 TELEVISION AND INTERACTIVITY. MAGAZINE ILLUSTRATION. KOMET/APPELBERG MAGAZINE FÖRLAG, 2007

4

5

4 BIKER CULTURE IN POPULAR MEDIA. MAGAZINE ILLUSTRATION. DYGNET RUNT/SYDSVENSKA DAGBLADET, 2007
5 MUSIC-BLOGS. MAGAZINE ILLUSTRATION. DYGNET RUNT/SYDSVENSKA DAGBLADET, 2007
6 GROWING VEHICLE MARKETS IN INDIA AND RUSSIA. MAGAZINE ILLUSTRATION. HALDEX DYNAMICS MAGAZINE, 2007

Pia Koskela

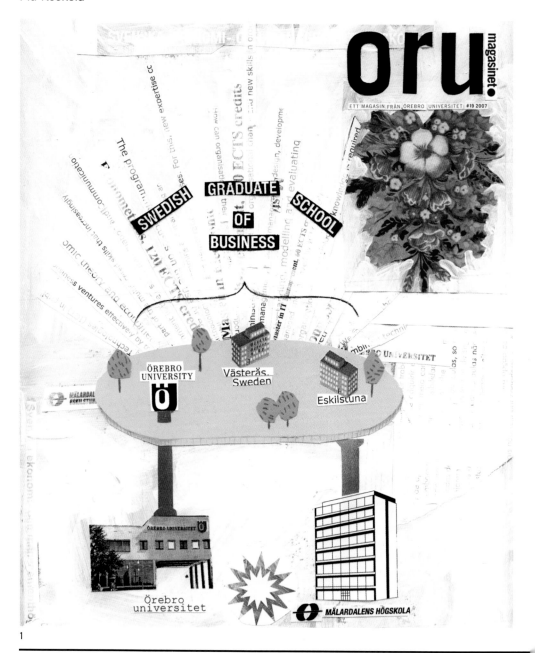

1

PIA KOSKELA FIRMA **ADDRESS** TYRA LUNDGRENS VÄG 3, SE-134 40 GUSTAVSBERG, SWEDEN
PHONE +46 (0)70 795 74 94 **E-MAIL** PIA@PIAKOSKELA.COM **WEBSITE** WWW.PIAKOSKELA.COM
SPECIALITY BOOK ILLUSTRATION, MAGAZINE ILLUSTRATION, POSTCARDS AND POSTERS
CLIENTS DAGENS NYHETER, SCA, AMS, ÖREBRO UNIVERSITY, DAMERNAS VÄRLD

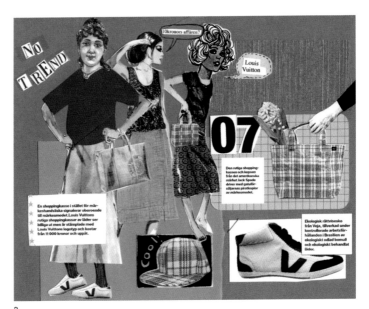

2

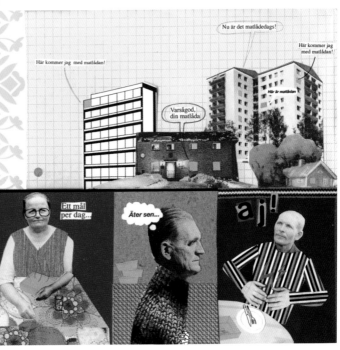

3

1 COVER ILLUSTRATION. SWEDISH GRADUATE SCHOOL. ÖREBRO UNIVERSITY, 2007
2 TREND 2007/FASHION. DAGENS NYHETER, 2007 3 MEALS ON WHEELS. RESTAURANGVÄRLDEN, 2007

Raimo Koskimies

1

RAIMO DESIGN & ILLUSTRATION **ADDRESS** KENNEDYGATAN 14 B, SE-414 73 GÖTEBORG, SWEDEN
PHONE +46 (0)31 14 81 99, +46 (0)73 968 55 09 **E-MAIL** RAIMO@DESILL.SE **WEBSITE** WWW.DESILL.SE
SPECIALITY GRAPHIC DESIGN, LOGOTYPES **CLIENTS** CPAC SYSTEMS, ELVINE

THERACEISON.SE
GOTHENBURG SWEDEN

1 SELF PROMOTION, 2006 2 THE RACE IS ON! SCREENPRINT ON T-SHIRTS. RAIMO DESIGN & ILLUSTRATION, 2006

Maria Källström

1

MARIA KÄLLSTRÖM FORM **ADDRESS** BLEKINGEGATAN 16, SE-118 56 STOCKHOLM, SWEDEN
PHONE +46 (0)70 820 73 58 **E-MAIL** MARIA@ILLIS.COM **WEBSITE** WWW.ILLIS.COM
SPECIALITY ADVERTISING, BOOK ILLUSTRATION, FASHION ILLUSTRATION **CLIENTS** LOWE BRINDFORS,
GROW PARTNERS, OGILVYONE, SIF

2

3

1 GRAPHIC DESIGN AND ILLUSTRATION. ONLINE FASHION STORE. TJINONA.SE, 2007
2-3 ILLUSTRATIONS. ONLINE FASHION STORE. TJINONA.SE, 2007

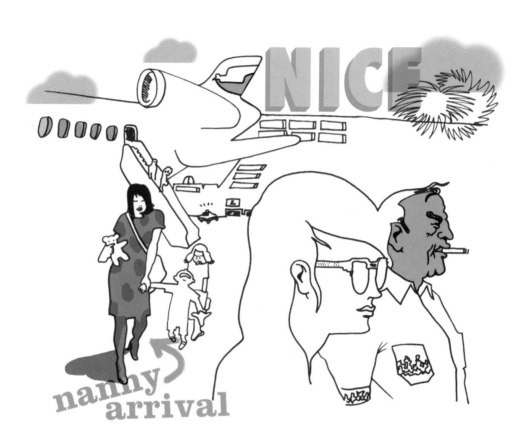

nanny arrival

5

6

4-6 CANNES LIONS REFLECTIONS. OWN PROJECT, 2005

Terry LeBlanc

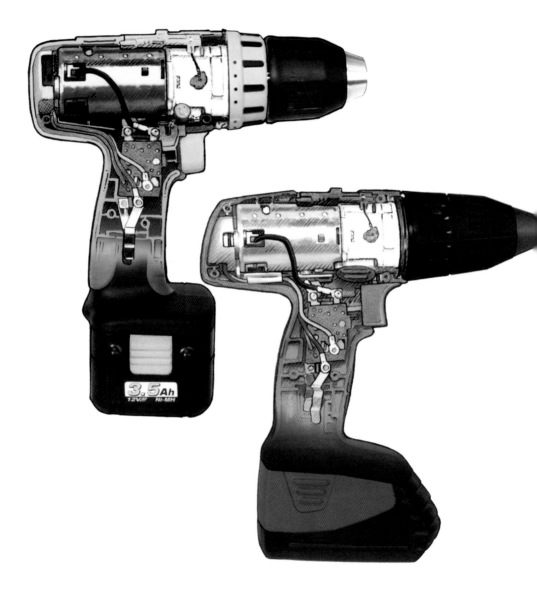

1

LEBLANC GRAPHICS **ADDRESS** TORGNYVÄGEN 19, SE-168 53 BROMMA, SWEDEN
PHONE +46 (0)8 579 705 88, +46 (0)70 964 23 55 **E-MAIL** TERRY@LEBLANC.SE **WEBSITE** WWW.LEBLANC.SE
SPECIALITY ADVERTISING, EDUCATIONAL MATERIAL, TECHNICAL ILLUSTRATION **CLIENTS** LIBER, ESSVE, SPARK DESIGN

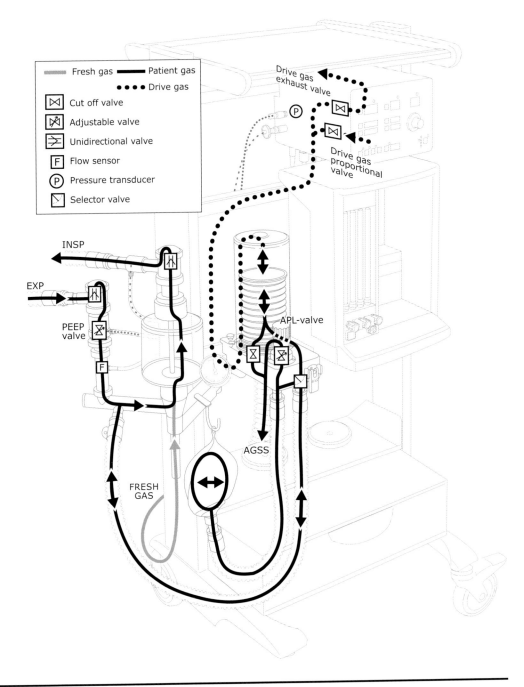

Fresh gas ▬▬▬ Patient gas
●●●● Drive gas

⊠ Cut off valve
⊠ Adjustable valve
⇥ Unidirectional valve
F Flow sensor
Ⓟ Pressure transducer
◿ Selector valve

Drive gas
exhaust valve

Ⓟ

Drive gas
proportional
valve

INSP

EXP

PEEP
valve

F

APL-valve

AGSS

FRESH
GAS

1 DRILL COMPARISON. ARTICLE ILLUSTRATION. BYGGARBETAREN, 2005
2 OPERATING MANUAL FOR AN ANESTHESIA SYSTEM. SIEMENS ELEMA, 2002

Katarina Lernmark

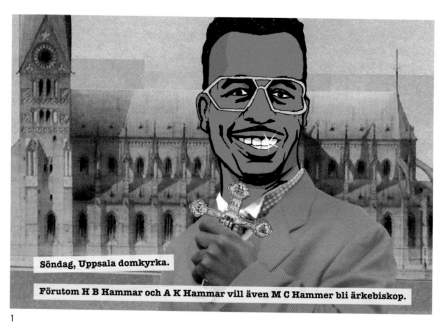

Söndag, Uppsala domkyrka.

Förutom H B Hammar och A K Hammar vill även M C Hammer bli ärkebiskop.

1

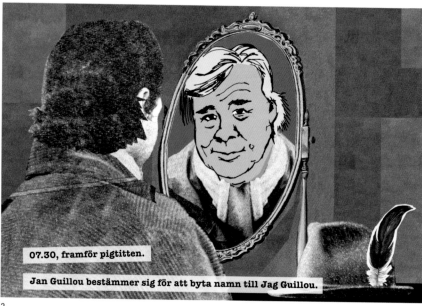

07.30, framför pigtitten.

Jan Guillou bestämmer sig för att byta namn till Jag Guillou.

2

KIDKAT DESIGN **ADDRESS** BORGARGATAN 4, NB, SE-117 34 STOCKHOLM, SWEDEN
PHONE +46 (0)8 668 11 30, +46 (0)73 672 27 27 **E-MAIL** KATARINA@KIDKAT.COM **WEBSITE** WWW.KIDKAT.COM
SPECIALITY ADVERTISING, BOOK ILLUSTRATION, MAGAZINE ILLUSTRATION **CLIENTS** FOKUS, KONTAKTEN,
BOKFÖRLAGET NATUR & KULTUR, EKAKAN, MILKO

3

1 MC HAMMAR. WEEKLY SATIRE. FOKUS, 2006 2 JAG GUILLOU. WEEKLY SATIRE. FOKUS, 2006
3 SHOPPING PAINKILLERS. MAGAZINE ILLUSTRATION. FOKUS, 2006

Lovisa Lesse

1

LESSE FORMGIVNING **ADDRESS** DYHULT, SVEDERNA, SE-614 90 SÖDERKÖPING, SWEDEN
PHONE +46 (0)121 220 24, +46 (0)70 759 64 39 **E-MAIL** LOVISA@LESSE.SE **WEBSITE** WWW.LESSE.SE
SPECIALITY ANIMATION, CHILDREN'S BOOKS ILLUSTRATION **CLIENTS** RABÉN & SJÖGREN, HAPPYLIFE,
SWEDISH NATIONAL SPACE BOARD, OLIKA FÖRLAG, SVENSK FILMINDUSTRI

2

3

1 JUNGLE. STAGE AND CHARACTER DESIGN FOR MODEL THEATRE. THEATRE PAPAGENA, 2007
2 BLOODHOUND. "HÄR KOMMER UPPFINNAR JOHANNA". CHILDREN'S BOOK. OLIKA FÖRLAG, 2007
3 JOHANNA AND GRUMPY OLLE. "HÄR KOMMER UPPFINNAR JOHANNA". CHILDREN'S BOOK. OLIKA FÖRLAG, 2007

5

6

4 CHEVRÉ. "IN SPACE NO-ONE CAN HERE YOU SNORE". TEXTBOOK. SWEDISH NATIONAL SPACE BOARD, 2005
5 GARAGE. ANIMATION. KONTRABUSS, 2005 6 RAMS MOVING. OWN PROJECT, 2005

Ola Lindahl

1

2

COOLA FILM AB **ADDRESS** YNGLINGAVÄGEN 7, SE-182 62 DJURSHOLM, SWEDEN
PHONE +46 (0)8 755 51 60, +46 (0)73 986 68 34 **E-MAIL** OLA@COOLAFILM.SE **WEBSITE** WWW.COOLAFILM.SE
SPECIALITY ANIMATION, CARTOONS, CONCEPTUAL DRAWING **CLIENTS** ADVERTISING AGANCIES, PUBLISHERS,
MAGAZINES, PUBLIC AUTHORITIES, COMPANIES

1 PRESENTATION. LÄNSFÖRSÄKRINGAR, 2006 2 CHRISTMAS TROUBLE. MOVIE SCENE. COOLAFILM, 2007
3 DRIVERS CERTIFICATE. SL, 2006

Bengt Lindberg

1

BENGT & LOTTA AB **ADDRESS** HOLLÄNDARGATAN 40, SE-113 59 STOCKHOLM, SWEDEN
PHONE +46 (0)8 660 65 15 **E-MAIL** BENGT@BENGT-LOTTA.SE **WEBSITE** WWW.BENGT-LOTTA.SE
SPECIALITY ADVERTISING, CHILDREN'S BOOKS ILLUSTRATION, POSTCARDS AND POSTERS
CLIENTS KLIPPANS YLLEFABRIK, STADSMISSIONEN, BOOKBINDERS DESIGN, GLEERUPS UTBILDNING, TRISS

2

1 MOUSE AND HAMSTER. OWN PROJECT 2 UPSIDE DOWN. OWN PROJECT

Tomas Lindell

1

2

TOMAS LINDELL ILLUSTRATION & GRAFISK FORM AB **ADDRESS** PARKVÄGEN 10, SE-723 46 VÄSTERÅS, SWEDEN
PHONE +46 (0)21 18 45 25 +46 (0)70 344 41 19 **E-MAIL** TOMAS@RITHUSET.SE **WEBSITE** WWW.RITHUSET.SE
SPECIALITY CONCEPTUAL DRAWING, FACTUAL GRAPHICS, MAGAZINE ILLUSTRATION
CLIENTS ALBERT BONNIERS FÖRLAG, VECKANS AFFÄRER, SIA GLASS, TETRA PAK, LIBER

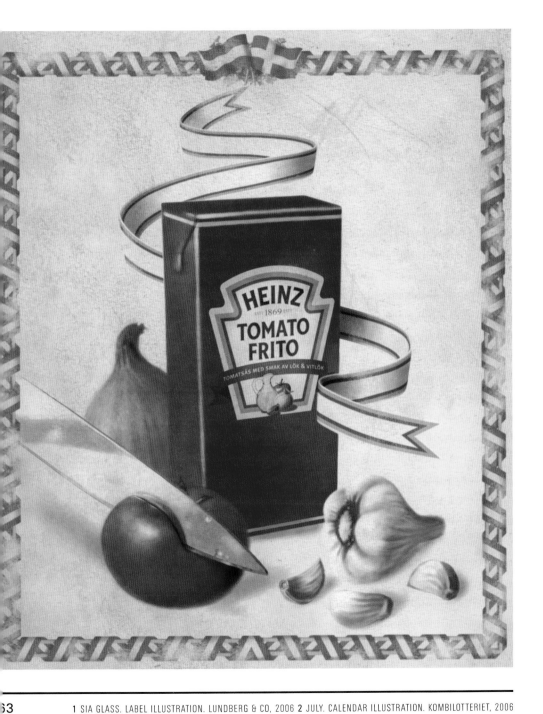

1 SIA GLASS. LABEL ILLUSTRATION. LUNDBERG & CO, 2006 2 JULY. CALENDAR ILLUSTRATION. KOMBILOTTERIET, 2006
3 HEINZ. ADVERTISEMENT. BATES RED CELL, 2007

Malin Turinna Lindgren

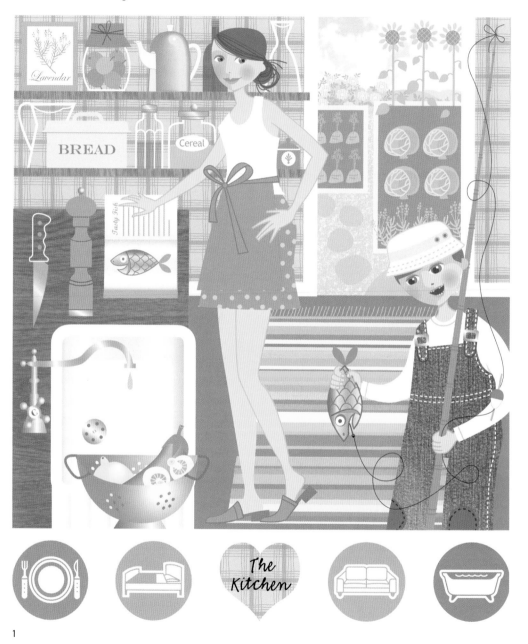

MA-LIN **ADDRESS** TIMMERMANSGATAN 43, SE-118 55 STOCKHOLM, SWEDEN **PHONE** +46 (0)70 834 66 78
E-MAIL MA-LIN@MALINLINDGREN.COM **WEBSITE** WWW.MALINLINDGREN.COM **SPECIALITY** CONCEPTUAL DRAWING,
CHILDREN'S BOOKS ILLUSTRATION, MAGAZINE ILLUSTRATION **CLIENTS** COUNTRY LIVING (UK), SYSTEMBOLAGET, BOOTS (UK),
TIDEN FÖRLAG, SVENSKA DAGBLADET **AGENCY** WWW.AMMO.SE, WWW.INKSHED.CO.UK (SEE ALIAS TURINNA GREN)

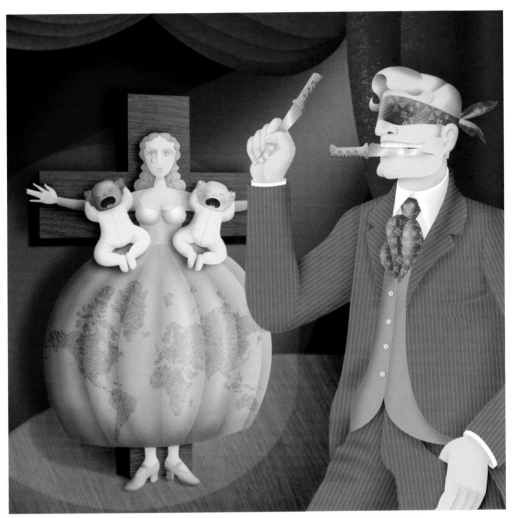

2

MOTHER EARTH
RESCUE KIT

GREEN VISION

3

1 THE KITCHEN. THE INKSHED ILLUSTRATION AGENCY, 2004
2 THE THREAT FROM MANKIND AGAINST MOTHER EARTH. THE INKSHED ILLUSTRATION AGENCY, 2007
3 THE REMEDIES FOR MOTHER EARTH. THE INKSHED ILLUSTRATION AGENCY, 2007

Eva Lindström

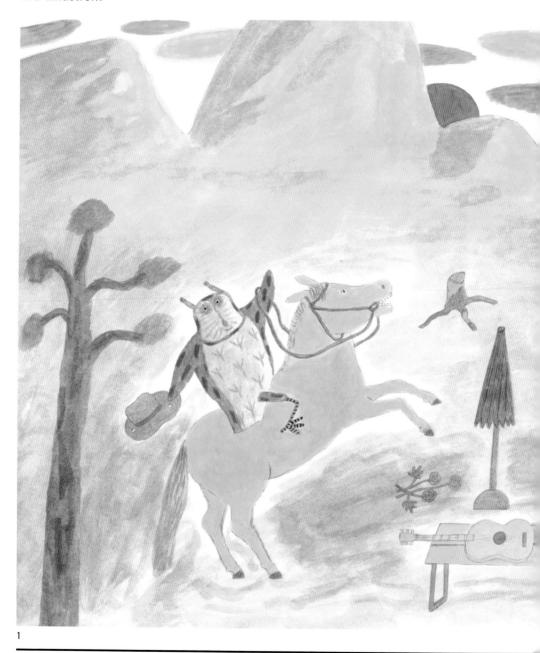

1

EVA LINDSTRÖM **ADDRESS** MASKINISTGATAN 9, SE-117 66 STOCKHOLM, SWEDEN
PHONE +46 (0)8 645 72 71, +46 (0)70 796 79 95 **E-MAIL** E_LINDSTROM@SWIPNET.SE
SPECIALITY BOOK ILLUSTRATION, CHILDREN'S BOOKS ILLUSTRATION **CLIENTS** ALFABETA PUBLISHERS,
RABÉN & SJÖGREN, BOKFÖRLAGET NATUR & KULTUR

1 "VID BERGETS LÅNGA BREDA FOT". CHILDREN'S BOOK. ALFABETA PUBLISHERS, 2003
2 "VILMA OCH MONA SPANAR OCH SMYGER". CHILDREN'S BOOK. ALFABETA PUBLISHERS, 2003

3 "JAG RYMMER". CHILDREN'S BOOK. ALFABETA PUBLISHERS, 2006
4 "MATS OCH ROJ – BERÄTTELSER OM ALLT MÖJLIGT". CHILDREN'S BOOK. ALFABETA PUBLISHERS, 2005

Joanna Lombard

1

JOANNA LOMBARD **ADDRESS** HERTIGVÄGEN 6, SE-126 52 HÄGERSTEN, SWEDEN
PHONE +46 (0)8 641 42 81, +46 (0)70 475 80 09 **E-MAIL** JOANNA.LOMBARD@HOME.SE
WEBSITE WWW.JOANNALOMBARD.COM **SPECIALITY** CHILDREN'S BOOKS ILLUSTRATION, MAGAZINE ILLUSTRATION,
SUPPLYING BOTH ILLUSTRATION AND TEXT **CLIENTS** BANG, ENSKEDESPELET, TEATER MILLICENT

1 THE NEIGHBOURHOOD. OWN PROJECT, 2006

Tina Lundgren

1

TL-ILLUSTRATION & FORM **ADDRESS** ALMSTRÄDET 5, SE-296 72 YNGSJÖ, SWEDEN
VISITING TORGASTRÄDET 8, YNGSJÖ **PHONE** +46 (0)44 24 02 87, +46 (0)70 404 84 97
E-MAIL TINALUNDGREN@TELIA.COM **WEBSITE** WWW.TINALUNDGREN.COM
SPECIALITY BOOK ILLUSTRATION, CHILDREN'S BOOKS ILLUSTRATION, PORTRAITS

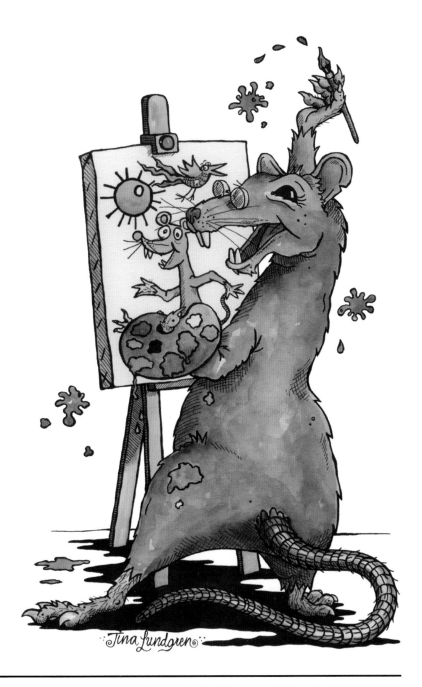

Tina Lundgren

1 ARE YOU COLD? CHRISTMAS CARD, 2004 **2** PAINTER RAT. OWN PROJECT, 2006

Johanna Lundqvist

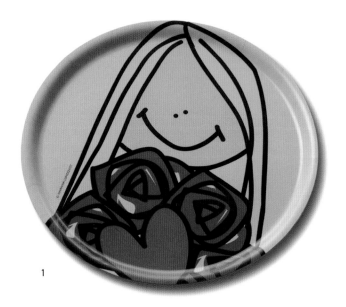

1

JOHANNA FORM & DESIGN **ADDRESS** KÖPMANSGATAN 9 C, SE-269 33 BÅSTAD, SWEDEN
PHONE +46 (0)431 724 11, +46 (0)73 952 20 23 **E-MAIL** INFO@JOHANNAFORMOCHDESIGN.SE
WEBSITE WWW.JOHANNAFORMOCHDESIGN.SE **SPECIALITY** GRAPHIC DESIGN
CLIENTS ORDNING & REDA PAPER AND DESIGN, SANDBERG TYG & TAPET

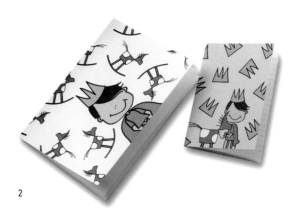

2

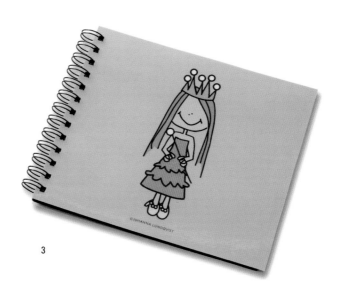

3

1 TRAY WITH ROSA. PRODUCT DESIGN. JOHANNA DESIGN COLLECTION, JOHANNA FORM & DESIGN, 2005
2 NOTEBOOKS WITH PRINCE. PAPER DESIGN. JOHANNA DESIGN COLLECTION, JOHANNA FORM & DESIGN, 2005
3 PHOTO ALBUM WITH PRINCESS SAGA. PAPER DESIGN. JOHANNA DESIGN COLLECTION, JOHANNA FORM & DESIGN, 2005

5

6

4 JULIA. PATTERN ON NOTEBOOK. PAPERDESIGN. ORDNING & REDA PAPER AND DESIGN, 2007
5 NEO. WALLPAPER FROM COLLECTION EMMA & MILTON. SANDBERG TYG & TAPET, 2006
6 JIM AND JACK. FABRIC AND WALLPAPER FROM COLLECTION EMMA & MILTON. SANDBERG TYG & TAPET, 2006

Bo Lundwall

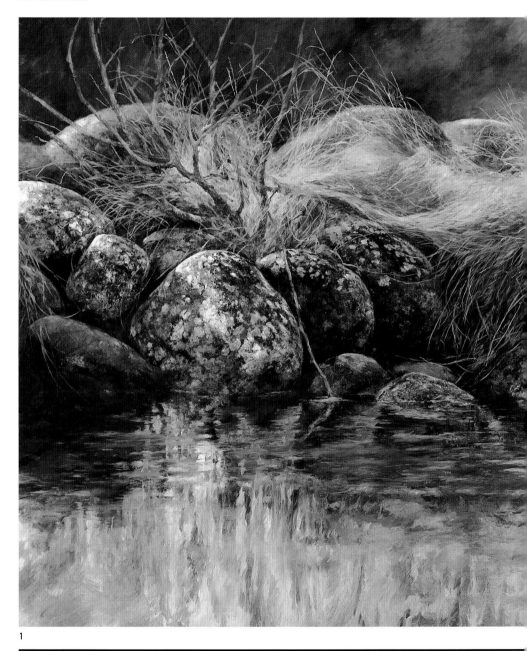

1

ATELJE BO LUNDWALL **ADDRESS** HULTSFREDS GÅRD, SE-577 36 HULTSFRED, SWEDEN **PHONE** +46 (0)495 106 72,
+46 (0)70 527 98 24 **E-MAIL** BO.LUNDWALL@EBOX.TNINET.SE **WEBSITE** WWW.BOLUNDWALL.COM
SPECIALITY BOOK ILLUSTRATION, EDUCATIONAL MATERIAL, PUBLIC COMMISSIONS **CLIENTS** FORMA PUBLISHING GROUP,
AMERICAN SWEDISH INSTITUTE (USA), LIBER, GALLERIES/PRIVATE CLIENTS, WWW.LANDMARKMEDIA.CA

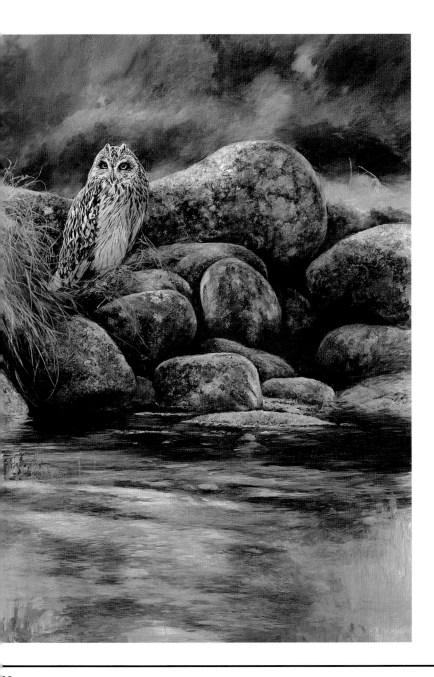

1 SHORT-EARED OWL. OIL PAINTING. ART EXHIBITION, 2004

Jens Magnusson

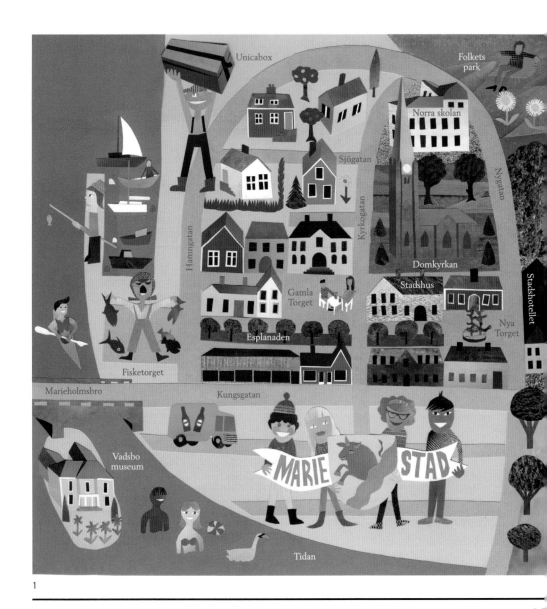

1

JENS MAGNUSSON DESIGN **ADDRESS** KOCKSGATAN 24, SE-116 24 STOCKHOLM, SWEDEN
PHONE +46 (0)8 641 37 64, +46 (0)70 918 26 72 **E-MAIL** JENS@JENSJENS.COM
WEBSITE WWW.JENSJENS.COM **SPECIALITY** ADVERTISING, BOOK COVERS, MAGAZINE ILLUSTRATION

1 MAP OF MARIESTAD. CATALOGUE COVER. NCC, 2006 2 AUSTRALIAN TENDENCIES. ELLE INTERIÖR, 2006

Ann-Sofi Marminge

1

ANN-SOFI MARMINGE FORMAT HB **ADDRESS** HANDELSVÄGEN 26, SE-122 32 ENSKEDE, SWEDEN
PHONE +46 (0)8 448 00 84, +46 (0)70 492 71 43 **E-MAIL** A@MARMINGE.COM **WEBSITE** WWW.MARMINGE.COM
SPECIALITY FACTUAL GRAPHICS, EDUCATIONAL MATERIAL, MAGAZINE ILLUSTRATION **CLIENTS** JOURNALISTGRUPPEN,
APPELBERG PUBLISHING AGENCY, BOKFÖRLAGET NATUR & KULTUR, PROFESSIONAL JOURNALS

28

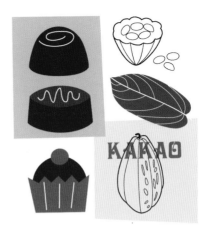

1 SOCIAL CURRENTS. KOMMUNAL, 2006 2 APPELBERG PUBLISHING AGENCY, 2007

Kati Mets

1

METSJAKOBSSON HB **ADDRESS** TEGELVIKSGATAN 44, SE-116 41 STOCKHOLM, SWEDEN
PHONE +46 (0)8 669 81 24, +46 (0)70 869 81 24 **E-MAIL** ILLUSTRATION@KATIMETS.SE **WEBSITE** WWW.KATIMETS.SE
SPECIALITY CARTOONS, EDUCATIONAL MATERIAL, MAGAZINE ILLUSTRATION **CLIENTS** BOKFÖRLAGET NATUR & KULTUR,
LIBER, SKTF-TIDNINGEN, THE EQUAL OPPORTUNITIES OMBUDSMAN, SKOLLEDAREN

1 COFFEE AND WHINING TIME! MAGAZINE ILLUSTRATION. NY KARRIÄR/SKTF-TIDNINGEN, 2006
2 "DOROTHEA IN THE KINGDOM OF THE DEAD". COMIC SHORT STORY, 2002/ANIMATED SHORT FILM, 2006

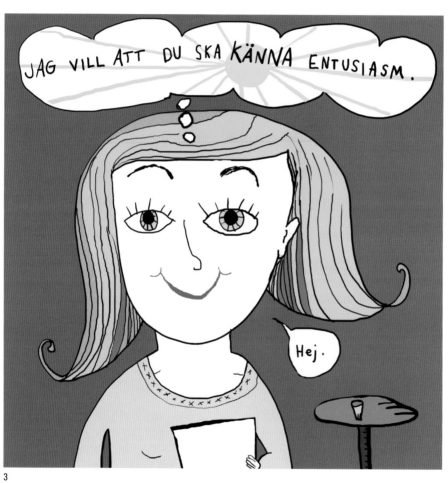

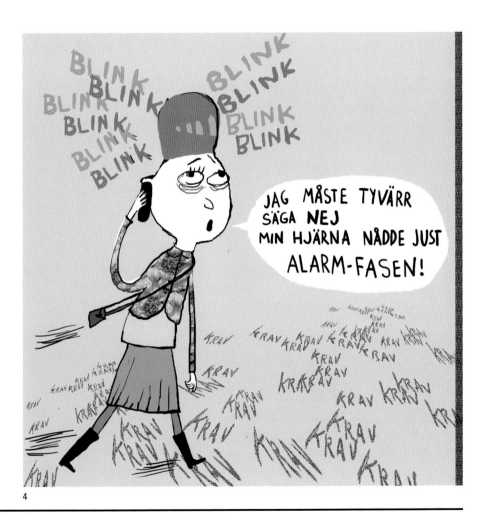

4

3 GIVE ME AN ENTHUSIASTIC RESPONSE. MAGAZINE ILLUSTRATION. NY KARRIÄR/SKTF-TIDNINGEN, 2006
4 I TAKE A RAIN CHECK 'CAUSE MY BRAINS JUST REACHED ALARM LEVELS! MAGAZINE ILLUSTRATION. SKTF-TIDNINGEN, 2006

Jeanette Milde

1

2

FORMILDE **ADDRESS** HÖGVALLAVÄGEN 7, SE-131 46 NACKA, SWEDEN
PHONE +46 (0)8 694 85 15, +46 (0)70 730 31 86 **WEBSITE** WWW.ILLUSTRATORSCENTRUM.SE
E-MAIL JEANETTE@FORMILDE.SE **SPECIALITY** BOOK COVERS, CHILDREN'S BOOKS ILLUSTRATION, CONCEPTUAL DRAWING
CLIENTS RABÉN & SJÖGREN, CENTERPARTIET, THE SWEDISH HANDICAP INSTITUTE, OGILVY, ARLA FOODS

1–2 "MIN DRÖM FÖR SVERIGE". BOOK BY MAUD OLOFSSON. CENTERPARTIET, 2006
3 WORKING ON THE RELATIONSHIP. VÅRA BARN

Lennart Moberg

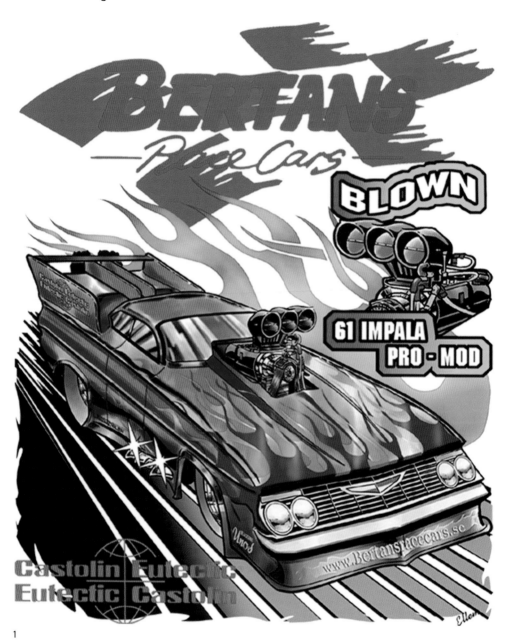

1

ELLEM TECKNINGSSERVICE **ADDRESS** KÖRSBÄRSVÄGEN 12, SE-616 90 ÅBY, SWEDEN
PHONE +46 (0)11 613 42, +46 (0)73 717 40 24 **E-MAIL** ELLEM@ALGONET.SE **WEBSITE** WWW.ALGONET.SE / ~ELLEM
SPECIALITY CARTOONS, EDUCATIONAL MATERIAL, PORTRAITS

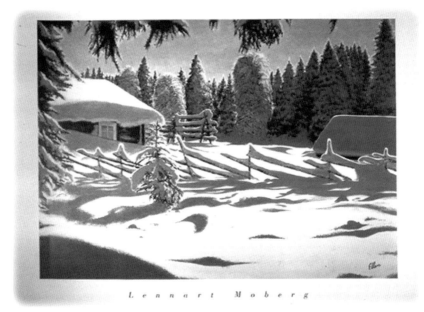

Lennart Moberg

2

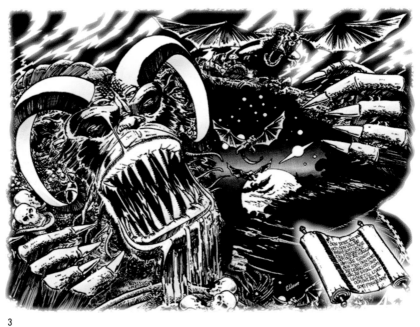

3

1 MOTIVE FOR T-SHIRT. DIGITAL ILLUSTRATION. BERTANS RACE CARS, 2004
2 MIDWINTER DAY. ACRYLIC PAINTING. IKEA, 1993 **3** MONSTER/JOHSUA 1:13. DIGITAL FANTASY PAINTING, 2005

Kari Modén

1

KARI MODÉN ILLUSTRATION **ADDRESS** HÖGBERGSGATAN 26 B, SE-116 20 STOCKHOLM, SWEDEN
PHONE +46 (0)70 483 34 50 **E-MAIL** KARI@MODEN.SE **WEBSITE** WWW.KARIMODEN.SE
SPECIALITY ADVERTISING, FASHION ILLUSTRATION, MAGAZINE ILLUSTRATION **CLIENTS** ARLA, APOTEKET,
THE GUARDIAN MAGAZINE (UK), VERO MODA MAGAZINE (DK) **AGENCY** WWW.VERONIQUE-DAYLE.COM

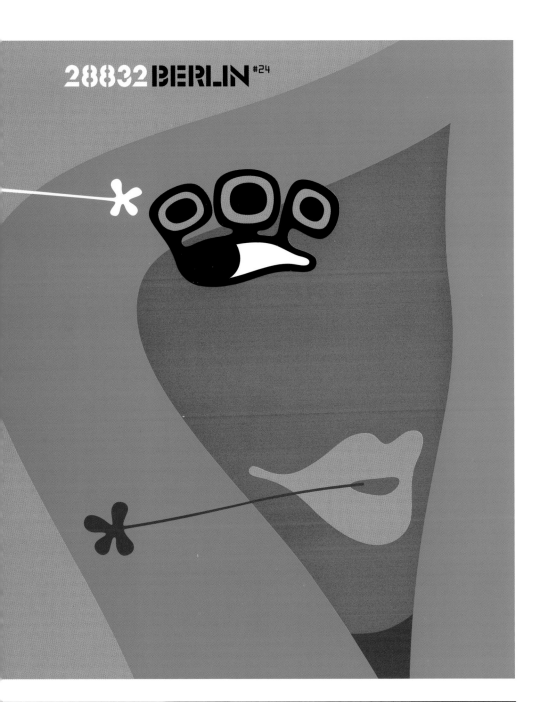

1 MAGAZINE COVER. 28832 BERLIN, MOSKITO (DE), 2007

Mrs Murphy / Malin Ehlin

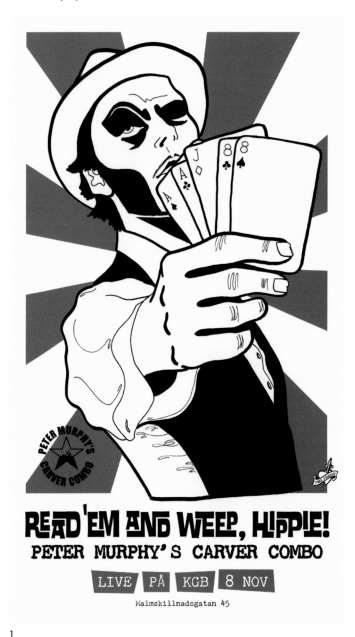

1

MRS MURPHY **ADDRESS** HÄGERSTENSVÄGEN 139, SE-126 48 STOCKHOLM, SWEDEN
PHONE +46 (0)70 985 13 06 **E-MAIL** MALIN@MRSMURPHY.SE **WEBSITE** WWW.MRSMURPHY.SE
SPECIALITY BOOK ILLUSTRATION, CARTOONS, POSTCARDS AND POSTERS **CLIENTS** UNIVERSAL MUSIC,
ÅHLÉNS, BONNIER AMIGO, FORUM BOKFÖRLAG, LYPSYL

1 READ 'EM AND WEEP HIPPIE! POSTER. PETER MURPHYS CARVER COMBO, 2006
2 TOM WAITS. "THE KITCHEN OF ROCK". FORUM BOKFÖRLAG, 2006

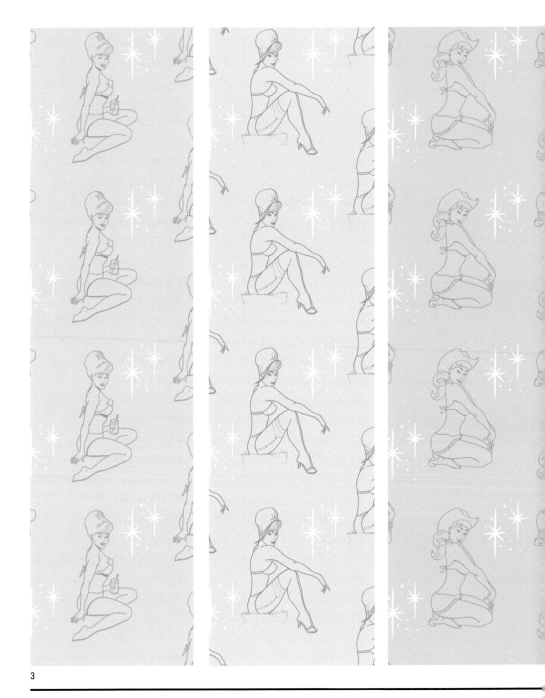

3

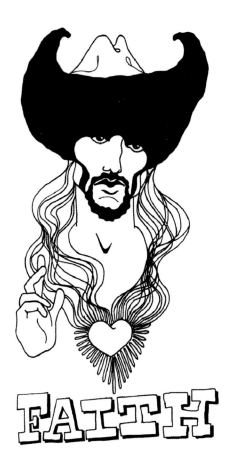

3 BE MY LITTLE BABY, MRS ROBINSON, THESE BOOTS ARE MADE FOR WALKING. WALLPAPER. MRS MURPHY, 2007
4 FAITH. ELMA RECORDS, 2006

Birgitta Nord

1

BIRGITTA NORD **ADDRESS** AXEL JOHNSONS VÄG 6, SE-182 31 DANDERYD, SWEDEN
PHONE +46 (0)8 622 65 56, +46 (0)70 461 11 94 **E-MAIL** BIRGITTA.NORD@SWIPNET.SE
SPECIALITY BOOK COVERS, MAGAZINE ILLUSTRATION, PORTRAITS
CLIENTS GUSKELOV, ETAC, INREDERIET, SKANSEN, SWEDISH TRAVELLING EXHIBITIONS

1 PORTRAIT. OWN PROJECT, 1996
2 TRAINEE – AGENT OF CHANGE OR MANAGERIAL CLONE? PERSONAL & LEDARSKAP/EPOK MEDIA

Tippan Nordén

1

TIPPAN NORDÉN **ADDRESS** LOMVÄGEN 491, SE-192 56 SOLLENTUNA, SWEDEN
PHONE +46 (0)8 758 12 58, +46 (0)70 729 21 83 **E-MAIL** TIPPAN@TIPPAN.COM **WEBSITE** WWW.TIPPAN.COM
SPECIALITY ADVERTISING, FASHION ILLUSTRATION, MAGAZINE ILLUSTRATION
CLIENTS ACNE, ELLE (IT), H&M, LIBER, VARIOUS MAGAZINES AND GALLERIES

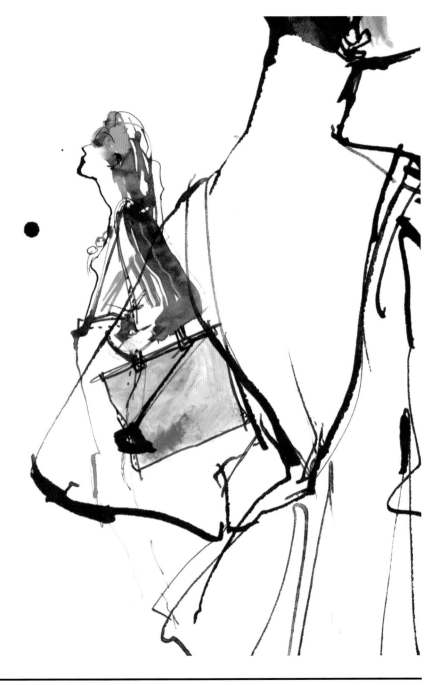

1 CRÈME CARAMEL. INVITATION CARD. OIL PAINTING. GALLERI ÄNGELN, 2004
2 TWO SISTERS. INSPIRATION FOR ACCESSORIES. ACNE PAPER, 2006

Ola Nyberg

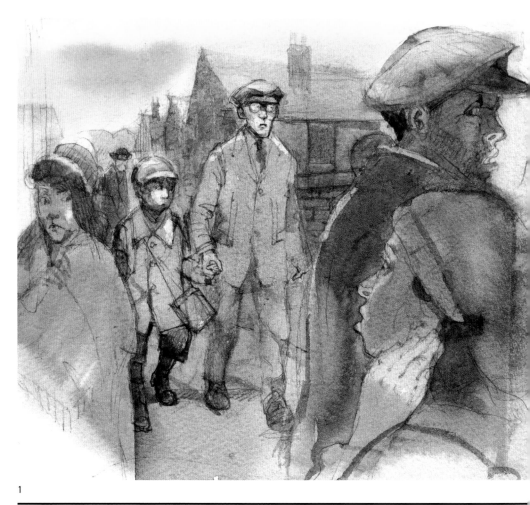

1

OLA NYBERG PRODUCTION **ADDRESS** BELLMANSGATAN 24, SE-118 47 STOCKHOLM, SWEDEN
PHONE +46 (0)8 640 35 49, +46 (0)70 278 40 69 **E-MAIL** OLA.NYBERG1@COMHEM.SE **WEBSITE** WWW.OLANYBERG.SE
SPECIALITY BOOK COVERS, BOOK ILLUSTRATION, EDUCATIONAL MATERIAL **CLIENTS** BOKFÖRLAGET NATUR & KULTUR,
LIBER, FORSKNING & FRAMSTEG, VERBUM FÖRLAG, ALFABETA PUBLISHERS

2

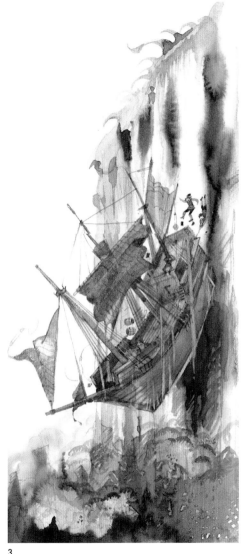

3

1 SHORT STORY BY P. ROBINSON. HEMMETS VECKOTIDNING, 2006
2 FANFAR. VIGNETTE FOR HISTORICAL TEXTBOOK. ALMQVIST & WIKSELL
3 A FLAT EARTH. WATERCOLOUR. FORSKNING & FRAMSTEG, 2006

Staffan Nylander

1

BILDEROCHSÅNT STAFFAN NYLANDER **ADDRESS** V STORGATAN 12, BOX 139, SE-551 13 JÖNKÖPING, SWEDEN
PHONE +46 (0)36 30 25 50, +46 (0)70 848 86 85 **E-MAIL** STAFFAN@NYLANDER.COM **WEBSITE** WWW.NYLANDER.COM
SPECIALITY FACTUAL GRAPHICS, MAGAZINE ILLUSTRATION, TECHNICAL ILLUSTRATION **CLIENTS** ADVERTISING AGENCIES,
INDUSTRIAL DESIGNERS, MAGAZINES, INDUSTRIES

1 SMALL TOWN. DIGITAL ILLUSTRATION FOR WEBSITE. SWEDISH RADIATION PROTECTION AUTHORITY, 2007
2 CUPBOARDS IN A CHANGING-ROOM. DIGITAL ILLUSTRATION FOR LEAFLET. TPG, 2006
3 A CUP OF COFFEE AND ORANGES. DIGITAL ILLUSTRATION. SELF PROMOTION, 2005

Ninni Oljemark

1

NINNI OLJEMARK AB **ADDRESS** HOLLÄNDARGATAN 8 B, SE-111 36 STOCKHOLM, SWEDEN
PHONE +46 (0)8 546 60 712 **E-MAIL** NINNI@KOMBINERA.SE **WEBSITE** WWW.KOMBINERA.SE
SPECIALITY BOOK COVERS, GRAPHIC DESIGN, MAGAZINE ILLUSTRATION

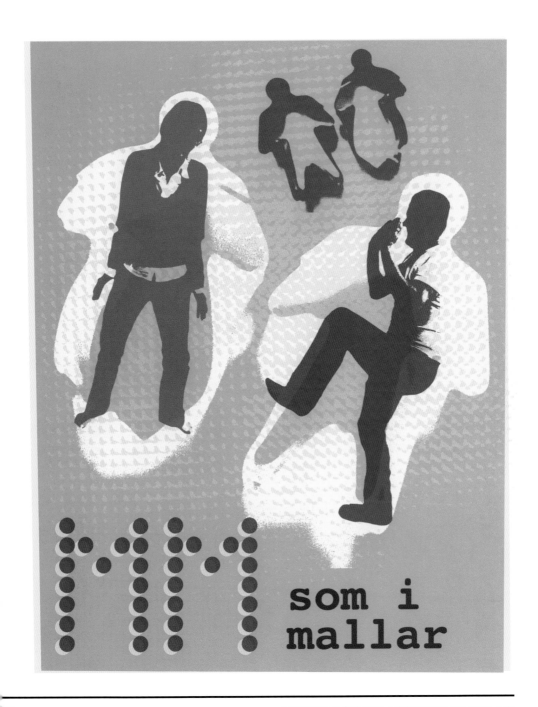

MM som i mallar

1 MAGAZINE ILLUSTRATION. LIBEROJOURNALEN/LIBERO, 2006
2 BOOK ILLUSTRATION. RFSL – THE SWEDISH FEDERATION FOR LESBIAN,
GAY, BISEXUAL AND TRANSGENDER RIGHTS, 2006

Andreas Olofsson

1

ANDREAS OLOFSSON ILLUSTRATION & GRAPHIC DESIGN **ADDRESS** VARVSGATAN 10 A, SE-117 29 STOCKHOLM, SWEDEN
PHONE +46 (0)70 747 32 73 **E-MAIL** ANDREAS@AOIG.NET **WEBSITE** WWW.AOIG.NET **SPECIALITY** ADVERTISING,
FACTUAL GRAPHICS, MAGAZINE ILLUSTRATION **CLIENTS** H&M, STADIUM, CAMPUS, SHORTCUT, FORSMAN & BODENFORS

2

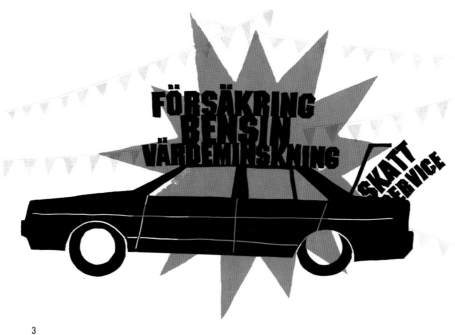

FÖRSÄKRING
BENSIN
VÄRDEMINSKNING
SKATT
SERVICE

3

1 WORKING AS A VOLUNTEER. MAGAZINE ILLUSTRATION. CAMPUS, 2006
2 BECOMING A JUDGE. MAGAZINE ILLUSTRATION. CAMPUS, 2006
3 THE DISADVANTAGES OF BUYING A NEW CAR. MAGAZINE ILLUSTRATION. KIA CARS/PRIME, 2007

Jan Olsson

1

2

JAN OLSSON FORM & ILLUSTRATION AB **ADDRESS** KAPTENSGATAN 8, SE-385 42 BERGKVARA, SWEDEN
PHONE +46 (0)486 200 02, +46 (0)70 555 12 61 **E-MAIL** JAN@JANOLSSON.COM **WEBSITE** WWW.JANOLSSON.COM
SPECIALITY GRAPHIC DESIGN, MAGAZINE ILLUSTRATION, PUBLIC COMMISSIONS **CLIENTS** TRR TRYGGHETSRÅDET,
OK-FÖRLAGET, MINISTRY OF THE ENVIRONMENT, THE SWEDISH ASSOCIATION OF GRADUATE ENGINEERS, NYNAS

11 1 SALE OF MUNICIPAL HOUSING. ARTICLE ILLUSTRATION. THE NATIONAL BOARD OF HOUSING, BUILDING AND PLANNING, 2007
2 HEALTH. KALMAR COUNTY COUNCIL, 2006 3 THE ART OF MOVING. ARTICLE ILLUSTRATON. SVENSKA BOSTÄDER, 2006

Lotta Persson

1

LOTTA PERSSON ILLUSTRATOR **ADDRESS** BANEHAGSGATAN 1 E, SE-414 51 GÖTEBORG, SWEDEN
PHONE +46 (0)31 42 41 43, +46 (0)73 392 44 49 **WEBSITE** WWW.LOTTAPERSSON.SE, WWW.LOTTAPERSSON.BLOGSPOT.COM
E-MAIL TECKNARE@LOTTAPERSSON.SE **SPECIALITY** CONCEPTUAL DRAWING, FACTUAL GRAPHICS, EDUCATIONAL MATERIAL
CLIENTS INFOMEDICA, SWEDISH NATIONAL INSTITUTE OF PUBLIC HEALTH, LIBER, ALMQVIST & WIKSELL, SAVE THE CHILDREN

2

3

1 THE MAN AT SCHIPOL AIRPORT. OWN PROJECT, 2006
2 THE TEASER. "STOP SMOKING!". SWEDISH NATIONAL INSTITUTE OF PUBLIC HEALTH, 2006
3 SHOW RESPECT. "LIVING TOGETHER". HJÄLLBOBOSTADEN, 2006

Linus Pettersson

1

EUROFIX **ADDRESS** KAPONJÄRGATAN 4 D, SE-413 02 GÖTEBORG, SWEDEN
PHONE +46 (0)31 711 42 98, +46 (0)70 826 24 37 **E-MAIL** LINUS.PETTERSSON1@COMHEM.SE
SPECIALITY CHILDREN'S BOOKS ILLUSTRATION, EDUCATIONAL MATERIAL, POSTCARDS AND POSTERS **CLIENTS** BONNIER
UTBILDNING, WARNE FÖRLAG, SVERIGES SLÄKTFORSKNINGSFÖRBUND, FÖRLAGET LUTFISKEN, THE CITY OF MALMÖ

1 AUGUST. CALENDAR ILLUSTRATION. SOCIALDEMOKRATISKA KOMBILOTTERIET, 2006

Johnny Påhlsson

1

2

ILLUSTRATION & DESIGN JOHNNY PÅHLSSON AB **ADDRESS** SADELGATAN 19, SE-194 72 UPPLANDS VÄSBY, SWEDEN
E-MAIL JOHNNYPAHLSSON@HOTMAIL.COM **WEBSITE** WWW.ILLUSTRATIONART.SE **PHONE** +46 (0)590 332 92,
+46 (0)76 245 13 12 **CLIENTS** ALBERT BONNIERS FÖRLAG, SCHIBSTED FÖRLAGEN, ALLERS FÖRLAG, PREMIUM PUBLISHING,
NORDISK FILM **SPECIALITY** BOOK COVERS, FILM AND VIDEO, MAGAZINE ILLUSTRATION **AGENCY** SAL BARRACCA ASS. (USA)

3

1 "VEM ÄR MIN PAPPA?". SERIAL STORY. HEMMETS VECKOTIDNING, 2007 **2** "BÖNPALLEN". SHORT STORY. ÅRET RUNT, 2005
3 "HANNAH, MELLOMSPILL". BOOK. COVER. SCHIBSTED FÖRLAGEN, 2006

Mia Raunegger

1

MIA RAUNEGGER DESIGN 4U2 **ADDRESS** BJÖRNDAMMSTERRASSEN 80, SE-433 42 PARTILLE, SWEDEN
PHONE +46 (0)31 44 83 87, +46 (0)73 040 00 84 **E-MAIL** MIA@DESIGN4U2.SE **WEBSITE** WWW.DESIGN4U2.SE
SPECIALITY ADVERTISING, GRAPHIC DESIGN, SUPPLYING BOTH ILLUSTRATION AND TEXT
CLIENTS CHALMERS UNIVERSITY OF TECHNOLOGY, GOTHENBURG UNIVERSITY

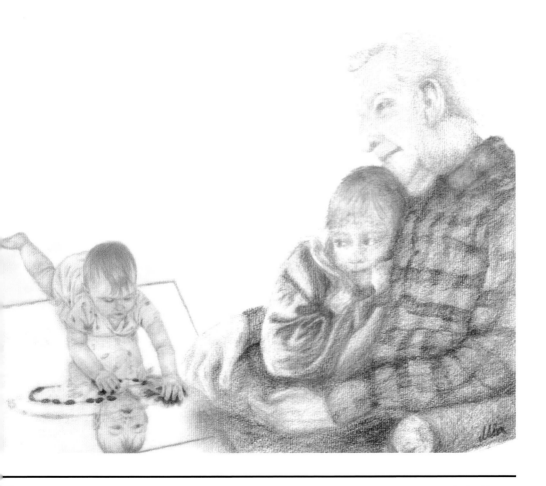

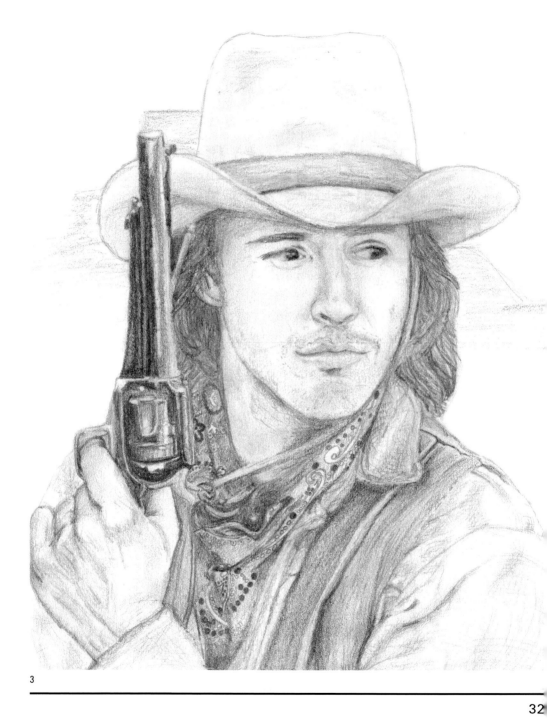

4

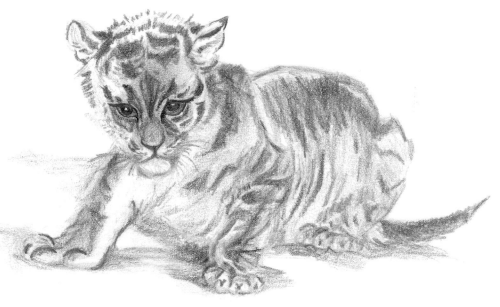

3 LUKE 4 STILL LIFE. INDIAN INK 5 TIGERBABY

Ann-Christin von Reybekiel

1

REYBEKIEL FORM AB **ADDRESS** TEGELVIKSGATAN 44, SE-116 41 STOCKHOLM, SWEDEN **PHONE** +46 (0)8 642 50 75
E-MAIL ACH@REYBEKIEL.SE **WEBSITE** WWW.REYBEKIEL.SE **SPECIALITY** FACTUAL GRAPHICS, GRAPHIC DESIGN, MAGAZINE
ILLUSTRATION **CLIENTS** ROYAL INSTITUTE OF TECHNOLOGY, THE SWEDISH CHEMICALS INSPECTORATE, SWEDISH LIBRARY
ASSOCIATION, THE SWEDISH INSTITUTE FOR INFECTIOUS DISEASE CONTROL, SWEDISH ENVIRONMENTAL RESEARCH INSTITUTE

"Vi önskar att vi kunde koppla en upplevelse till de molekyler vi säljer."

3

1 PROGRAMMES. ROYAL INSTITUTE OF TECHNOLOGY
2 THE IMPORTANCE OF EXPERIENCES IN BUSINESS. THE ROYAL SWEDISH ACADEMY OF ENGINEERING SCIENCES
3 ROOMS – BEFORE AND AFTER. FAMILY MAGAZINE, IKEA

Li Rosén Zobec

1

ILLLI, ILLUSTRATOR LI ROSÉN **ADDRESS** HANTVERKARGATAN 77, SE-112 38 STOCKHOLM, SWEDEN
PHONE +46 (0)8 32 52 35, +46 (0)70 939 98 93 **E-MAIL** LI.ROSEN@ILLLI.SE **WEBSITE** WWW.ILLLI.SE
SPECIALITY ADVERTISING, GRAPHIC DESIGN, MAGAZINE ILLUSTRATION **CLIENTS** BONNIER TIDSKRIFTER,
COCA-COLA, MILKO, NOVARTIS, WRIGLEY'S

1 RETAIL CAMPAIGN. WRIGLEY'S, 2006 2 TRADE FAIR AND THE WEB. UNIVERSITY OF KALMAR, 2006
3 CORPORATE PRESENTATION. ANELDA, 2006

Joanna Rubin Dranger

1
2

JOANNA RUBIN DRANGER **ADDRESS** ODENGATAN 13, SE-114 24 STOCKHOLM, SWEDEN
PHONE +46 (0)8 791 90 84, +46 (0)70 878 55 96 **E-MAIL** INFO@JOANNARUBINDRANGER.COM
WEBSITE WWW.JOANNARUBINDRANGER.COM **SPECIALITY** SUPPLYING BOTH ILLUSTRATION AND TEXT

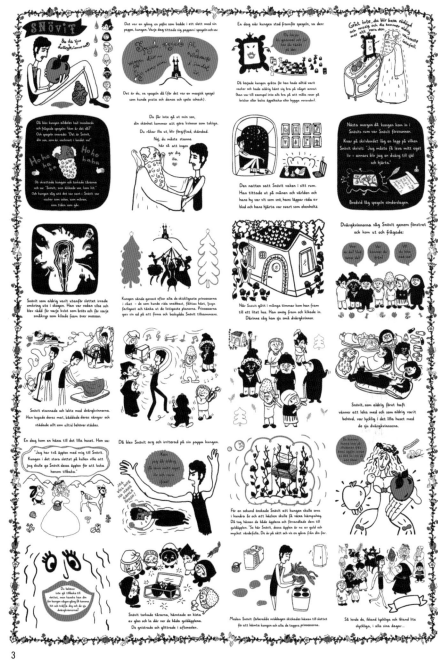

1 LAST MINUTE CHRISTMAS WITH MISS TERRIFIED. AFTONBLADET, CHRISTMAS EVE 2006
2 MISS REMARKABLE DOLL 3 SNOW WHITE AND THE SEVEN DWARF WOMEN. POSTER, 2006

Kristian Russell

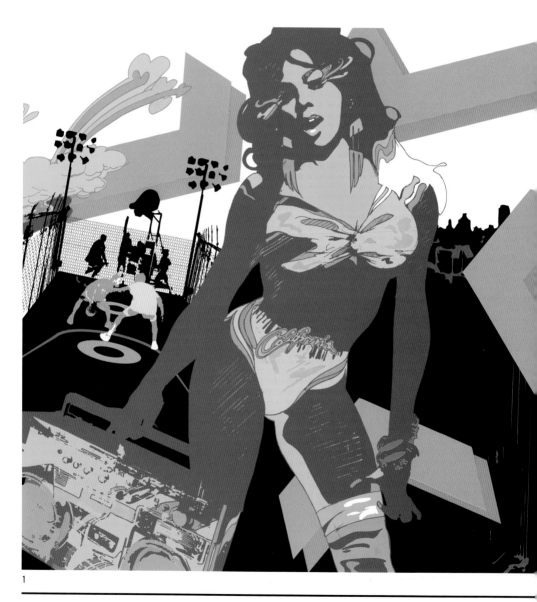

1

GHETTO DESIGN **ADDRESS** VERKSTADSGATAN 11, SE-117 36 STOCKHOLM, SWEDEN
PHONE +46 (0)70 812 92 94 **E-MAIL** KRISTIAN@BIGACTIVE.COM **WEBSITE** WWW.KRISTIAN-RUSSELL.COM
SPECIALITY ADVERTISING, FASHION ILLUSTRATION **CLIENTS** DIESEL
AGENCY WWW.BIGACTIVE.COM, WWW.ART-DEPT.COM, WWW.CWCTOKYO.COM, WWW.AGENTBAUER.COM

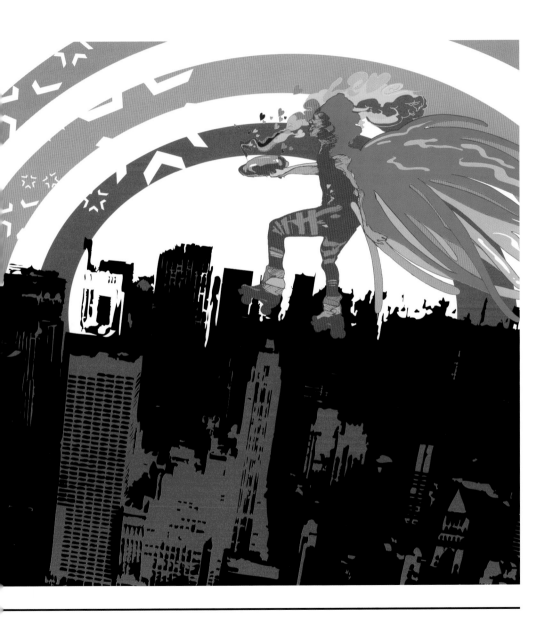

1 MARKETING IMAGE FOR LIFESTYLE NETWORK. TRIG.COM/ADOCCA ENTERTAINMENT, 2007

Odd Sandberg

1

ODD SANDBERG ILLUSTRATION **ADDRESS** BARKABY GÅRD, SE-178 93 DROTTNINGHOLM, SWEDEN
PHONE +46 (0)8 759 05 39, +46 (0)73 331 53 41 **E-MAIL** ODD.SANDBERG@TELE2.SE
SPECIALITY BOOK ILLUSTRATION, CHILDREN'S BOOKS ILLUSTRATION

2

3

1-3 "KIDNAPPAD". BOOK. COVER AND ILLUSTRATIONS. RABÉN & SJÖGREN, 2006

Martin Sandström

1

SANDSTRÖM DESIGN **ADDRESS** BANKGATAN 28, SE-223 54 LUND, SWEDEN
PHONE +46 (0)73 386 14 86 **E-MAIL** INFO@SANDSTROMDESIGN.SE **WEBSITE** WWW.SANDSTROMDESIGN.SE
SPECIALITY GRAPHIC DESIGN, ILLUSTRATING WEB PAGES AND MULTIMEDIA, MAGAZINE ILLUSTRATION
CLIENTS INTERNATIONAL AIDS SOCIETY, FRYSHUSET, SONY ERICSSON

2

1 CHRISTMAS WRAPPING PAPER 2 SELF PROMOTION

4

5

3 ADVERTISEMENT FOR CONFERENCE ORGANIZER. FRYSHUSET
4–5 ILLUSTRATIONS FOR GARDENING WEBSITE. CAP & DESIGN

Hans Sjögren

ILLUSTRATION OCH GRAFISK FORM **ADDRESS** GAMMELUDDSVÄGEN 41, SE-132 46 SALTSJÖ-BOO, SWEDEN
PHONE +46 (0)8 55 61 41 34, +46 (0)70 875 09 44 **E-MAIL** H.SJOGREN@TELIA.COM **WEBSITE** WWW.MOSEBACKEMEDIA.SE
SPECIALITY FACTUAL GRAPHICS, EDUCATIONAL MATERIAL **CLIENTS** BOKFÖRLAGET NATUR & KULTUR, BOKFÖRLAGET
ATLANTIS, THE SWEDISH ENVIRONMENTAL PROTECTION AGENCY, GLEERUPS UTBILDNING, SKB

Tjuv-udden

Tjuvviken

Västerskogen

Norrudden

Norrviken

Lång-ängen

Lång-ängen

Stormaren

Norr-ängen

Norrskogen

Adams-skogen

Adams-udden

Blötängs-backen

Lad-ängen

Ladängsbacken

Idbacken

Adams-ängen

Österskogen

Svartviken

Id-viken

Saltings-slätten

Idviksudden

Djupviken

Blackudden

Tallgrundet

B

1 "ÄNGSÖ – NATIONALPARK I ROSLAGEN". BOOK ILLUSTRATION.
THE SWEDISH ENVIRONMENTAL PROTECTION AGENCY, HILMAS FÖRLAG, 2006

Andrea Sjöström

1

ANDREA SJÖSTRÖM **ADDRESS** HORNSGATAN 52, SE-118 21 STOCKHOLM, SWEDEN
PHONE +46 (0)8 55 60 08 64, +46 (0)70 713 12 96 **E-MAIL** ANDREA@ANDREASJOSTROM.SE
WEBSITE WWW.ANDREASJOSTROM.SE **SPECIALITY** ADVERTISING, FASHION ILLUSTRATION, MAGAZINE ILLUSTRATION
CLIENTS ALCRO DESIGNERS, DAMERNAS VÄRLD, ENIRO, GRINGO, KING

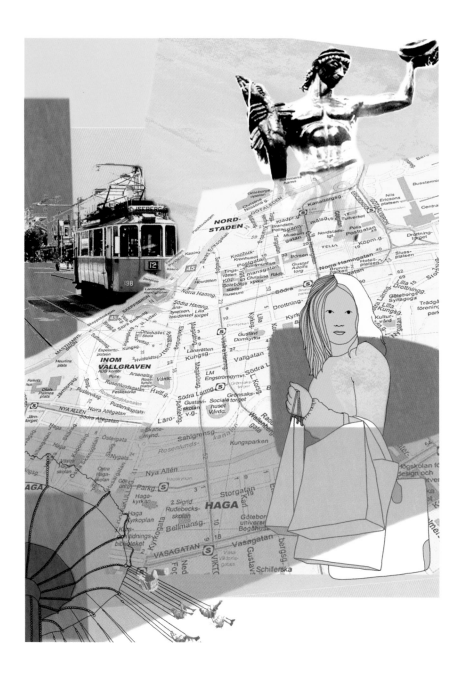

1 MAGAZINE ILLUSTRATION. DAMERNAS VÄRLD 2 COVER ILLUSTRATION. SWEDISH YELLOW PAGES

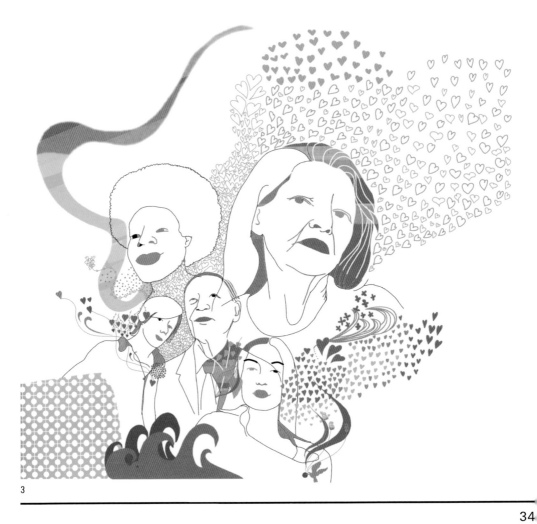

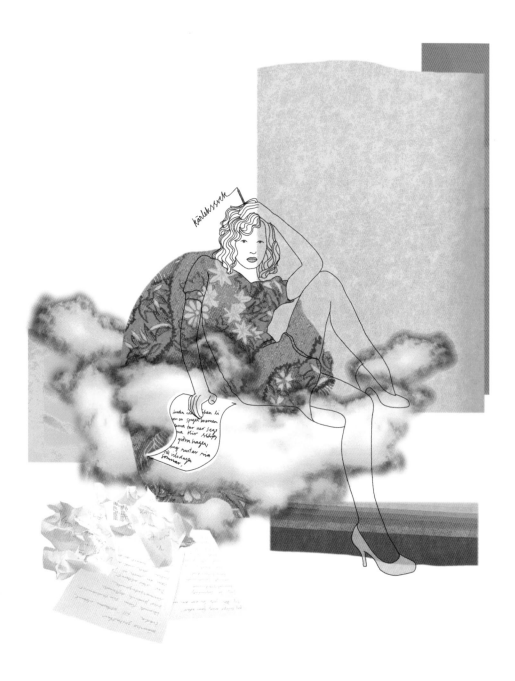

Annika Sköld Lindau

1

ANNIKA SKÖLD LINDAU ILLUSTRATIONER **ADDRESS** STORA NYGATAN 44, SE-111 27 STOCKHOLM, SWEDEN
PHONE +46 (0)70 722 21 43 **E-MAIL** ANNIKA@STOCKHOLMILLUSTRATION.COM **WEBSITE** WWW.STOCKHOLMILLUSTRATION.COM
SPECIALITY CONCEPTUAL DRAWING, MAGAZINE ILLUSTRATION, PUBLIC COMMISSIONS **CLIENTS** ARLA, RIKSTEATERN,
STOCKHOLM COUNTY COUNCIL, NORSTEDTS JURIDIK, SWEDISH NATIONAL COUNCIL FOR CULTURAL AFFAIRS

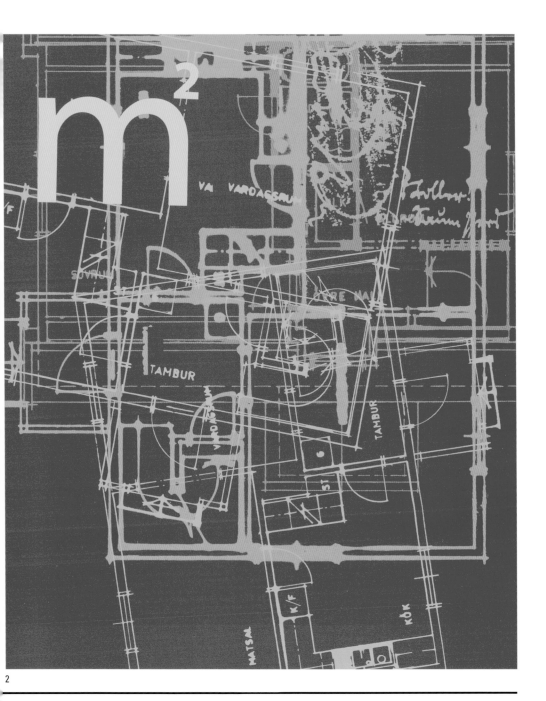

1 HAPPINESS. SYMBOL. RIKSTEATERN, 2006 **2** TENANCY RIGHT. COVER ILLUSTRATION. NORSTEDTS JURIDIK, 2006

Ebba Strid Udikas

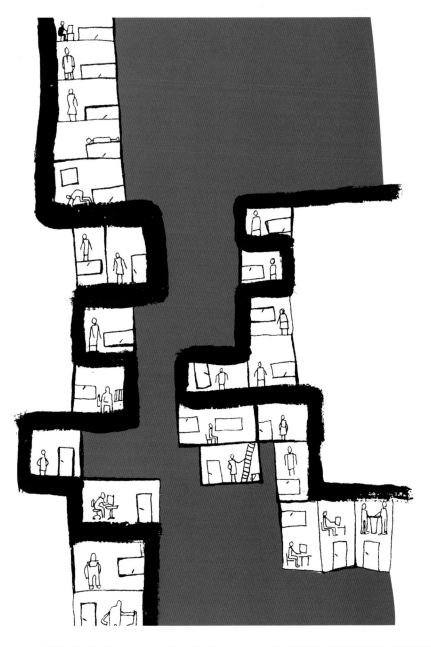

1

EBBAS VÄRLD **ADDRESS** BERGANÄSVÄGEN 16, SE-135 52 TYRESÖ, SWEDEN **VISITING** STORA NYGATAN 33, STOCKHOLM
PHONE +46 (0)70 797 47 71 **E-MAIL** EBBA@EBBASVARLD.SE **WEBSITE** WWW.GRAFISKFORM-ES.SE
SPECIALITY CONCEPTUAL DRAWING, MAGAZINE ILLUSTRATION, PORTRAITS **CLIENTS** PUBLISHING HOUSES, MAGAZINES

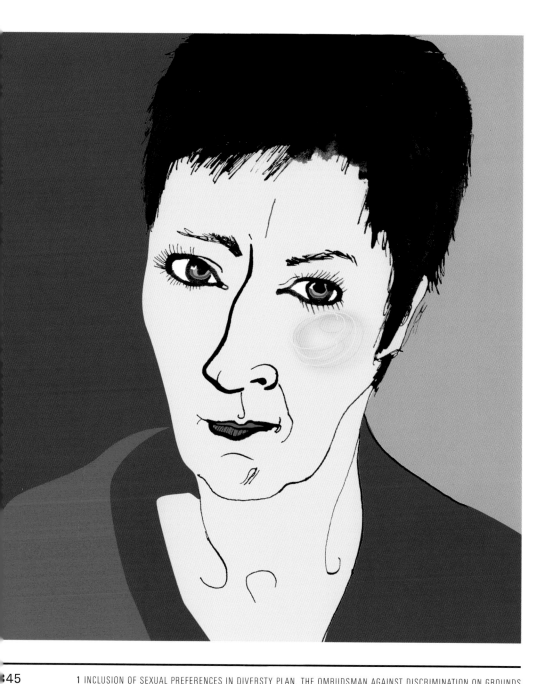

1 INCLUSION OF SEXUAL PREFERENCES IN DIVERSTY PLAN. THE OMBUDSMAN AGAINST DISCRIMINATION ON GROUNDS OF SEXUAL ORIENTATION 2 PORTRAIT OF MONA SAHLIN. MAGAZINE ILLUSTRATION. ARBETSMARKNADEN/AMS

Claes Stridsberg

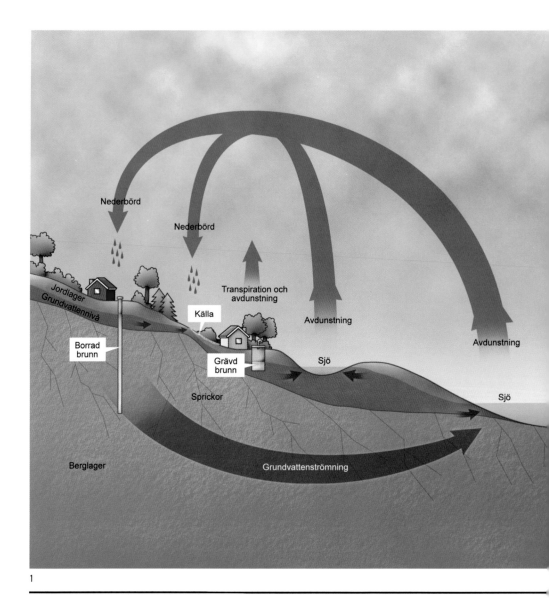

Nederbörd

Nederbörd

Transpiration och
avdunstning

Källa

Avdunstning

Jordlager

Grundvattennivå

Avdunstning

Borrad
brunn

Grävd
brunn

Sjö

Sprickor

Sjö

Berglager

Grundvattenströmning

1

GOOSEPEN PRODUCTIONS AB **ADDRESS** UVEDALSGATAN 52, SE-589 31 LINKÖPING, SWEDEN
PHONE +46 (0)13 15 15 29, +46 (0)70 747 18 44 **E-MAIL** CLAES@GOOSEPEN.SE **WEBSITE** WWW.GOOSEPEN.SE
SPECIALITY ANIMATION, CARTOONS, ILLUSTRATING WEB PAGES AND MULTIMEDIA **CLIENTS** SEKOTIDNINGEN,
VOLVO CARS, CHALMERS UNIVERSITY OF TECHNOLOGY, TELIA, THE NATIONAL BOARD OF HEALTH AND WELFARE

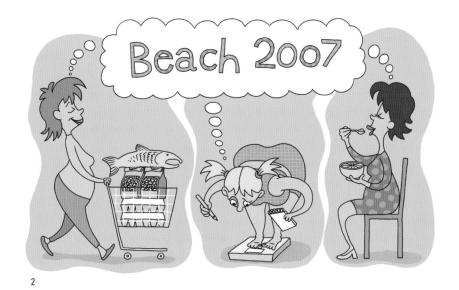

2

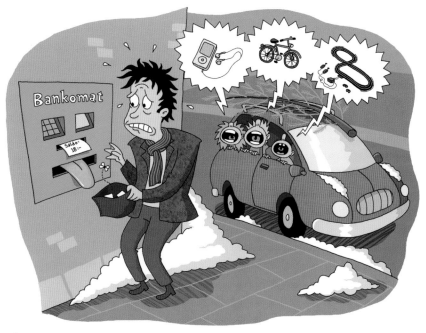

3

1 "ATT ANLÄGGA BRUNN". BOOKLET. THE NATIONAL BOARD OF HEALTH AND WELFARE/SGU, 2005
2 SLIMMING. ARTICLE ILLUSTRATION. SEKOTIDNINGEN, 2007
3 FINANCIAL ANXIETY BEFORE CHRISTMAS. ARTICLE ILLUSTRATION. SEKOTIDNINGEN, 2006

Svante Ström

1

SVANTE STRÖM DESIGN **ADDRESS** PILÖRTSVÄGEN 2, SE-277 30 KIVIK, SWEDEN
PHONE +46 (0)414 700 48, +46 (0)70 991 83 92 **E-MAIL** SS@SVANTEDESIGN.SE **WEBSITE** WWW.SVANTEDESIGN.SE
SPECIALITY FACTUAL GRAPHICS, MAGAZINE ILLUSTRATION, TECHNICAL ILLUSTRATION **CLIENTS** ALLT OM HISTORIA,
TRELLEBORG AUTOMOTIVE, HISTORISKA MEDIA, RHR CORPORATE COMMUNICATION, SYDSVENSKA DAGBLADET

1 COLLAGE OF PRODUCTS. TRELLEBORG AUTOMOTIVE/RHR CORPORATE COMMUNICATION, 2006

Anders Suneson

1

ANDERS SUNESON TECKNADE BILDER **ADDRESS** PETERSON-BERGERS VÄG 4, SE-832 96 FRÖSÖN, SWEDEN
PHONE +46 (0)63 441 53, +46 (0)70 580 84 69 **WEBSITE** WWW.ANTILOOPFILM.SE, WWW.TECKNADEBILDER.SE
E-MAIL ANDERS@TECKNADEBILDER.SE **SPECIALITY** CHILDREN'S BOOKS, EDUCATIONAL MATERIAL, MAGAZINE ILLUSTRATION
CLIENTS SKISTAR ÅRE, JAMTLI MUSEUM, LIBER, SYRE ADVERTISING AGENCY, PEARSON EDUCATION (UK)

1 PIRATE SPAREPARTS. CARTOON. ELINSTALLATÖREN, 2006
2 MOTORBOAT. EASY-TO-READ SCHOOLBOOK. LIBER, 2005

Lisbeth Svärling

1

LISBETH SVÄRLING **ADDRESS** STORA BADHUSGATAN 30, SE-411 21 GÖTEBORG, SWEDEN
PHONE +46 (0)31 13 08 41, +46 (0)70 990 33 56 **E-MAIL** SVARLING@BADHUSGATAN.COM **WEBSITE** WWW.SVARLING.SE
SPECIALITY ADVERTISING, COMICS, MAGAZINE ILLUSTRATION **CLIENTS** ADIDAS, TONY & GUY, COOKIE MAGAZINE,
HAPPY F&B, ANR.BBDO **AGENCY** SÖDERBERG AGENTUR

2

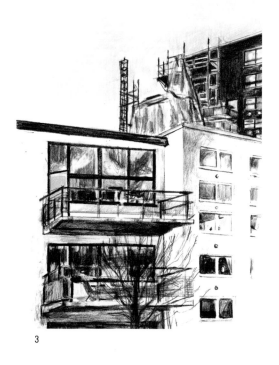

3

1 OWN PROJECT, 2006 2 MOTIVE FOR SWEATSHIRT AND T-SHIRT. MINIMARKET, 2007
3 ADVERTISEMENT. HYRESGÄSTFÖRENINGEN/ANR.BBDO, 2006

Syster Diesel / Annika Bryngelson

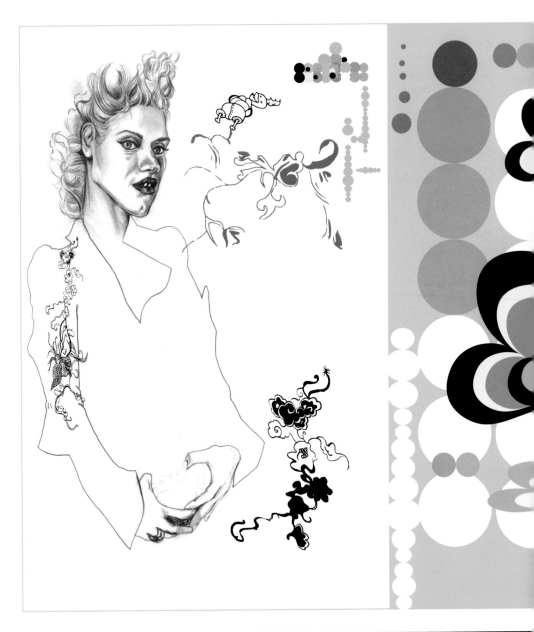

SYSTER DIESEL HB **ADDRESS** LERBERGETS BYAVÄG 11, SE-263 52 LERBERGET, SWEDEN
VISITING SHIP, BREDGATAN 11, 1 TR, HELSINGBORG **PHONE** +46 (0)70 630 71 93 **E-MAIL** ANNIKA@SYSTERDIESEL.COM
WEBSITE WWW.SYSTERDIESEL.COM **SPECIALITY** ADVERTISING, CONCEPTUAL DRAWING, MAGAZINE ILLUSTRATION

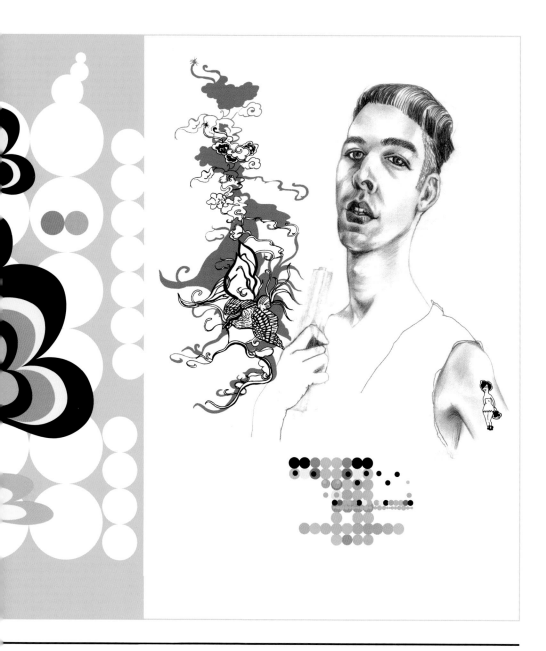

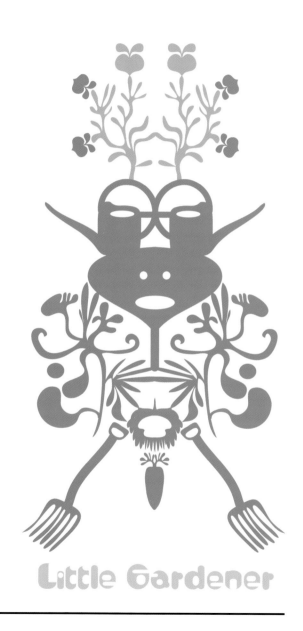

Little Gardener

Li Söderberg

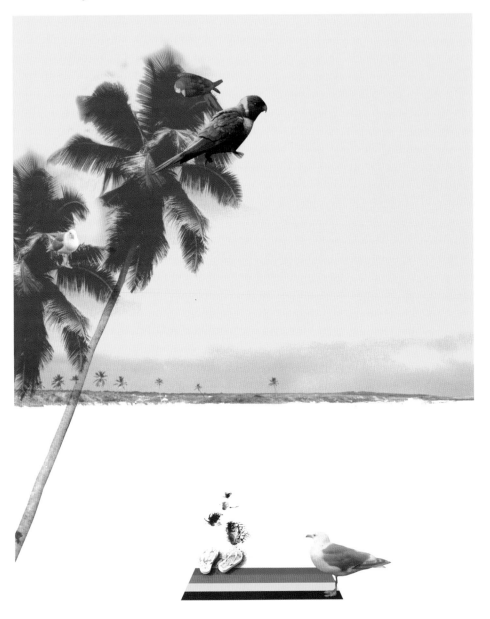

1

LI SÖDERBERG **ADDRESS** ERSTAGATAN 32-34, SE-116 36 STOCKHOLM, SWEDEN
PHONE +46 (0)70 872 02 05 **WEBSITE** WWW.LISODERBERG.SE **SPECIALITY** BOOK COVERS, MAGAZINE ILLUSTRATION,
CHILDREN'S BOOKS ILLUSTRATION **CLIENTS** THE GOTHENBURG CITY THEATRE, BOKFÖRLAGET NATUR & KULTUR,
ERIKSSON & LINDGREN BOKFÖRLAG, ALBERT BONNIERS FÖRLAG, THE ROYAL ARMOURY

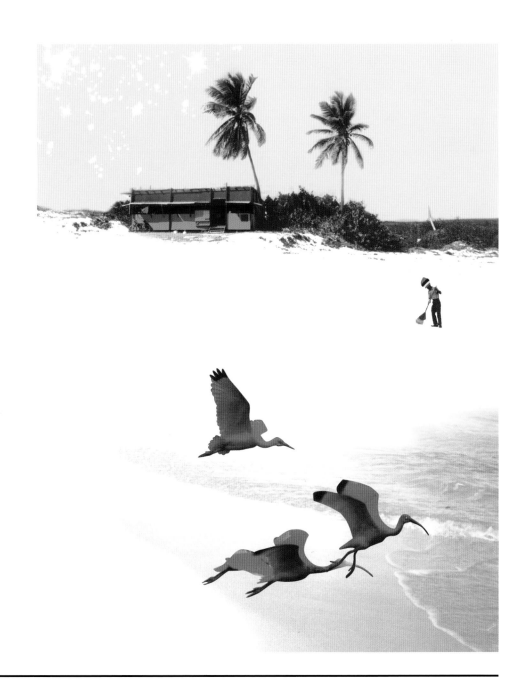

3

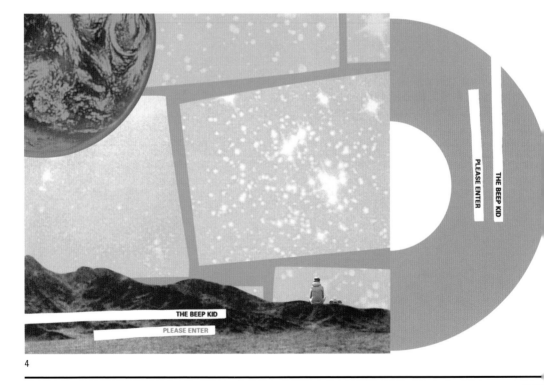

4

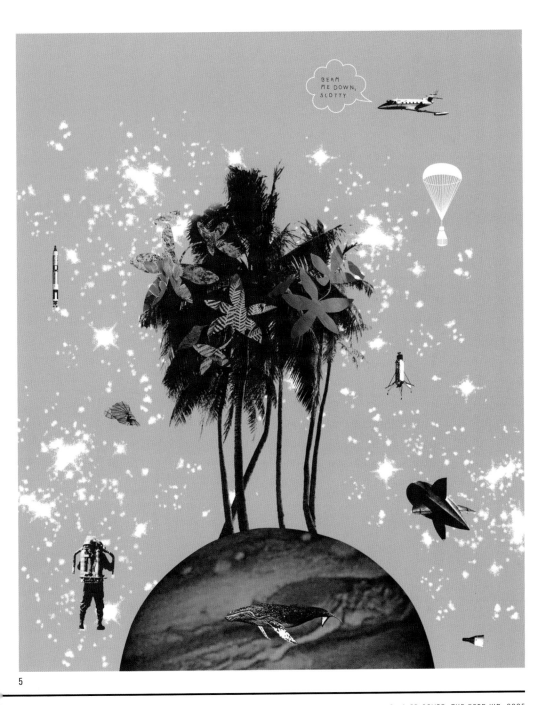

3–4 CD COVER. THE BEEP KID, 2005
5 UTOPIA. FAKTUM, 2005

Karin Södergren

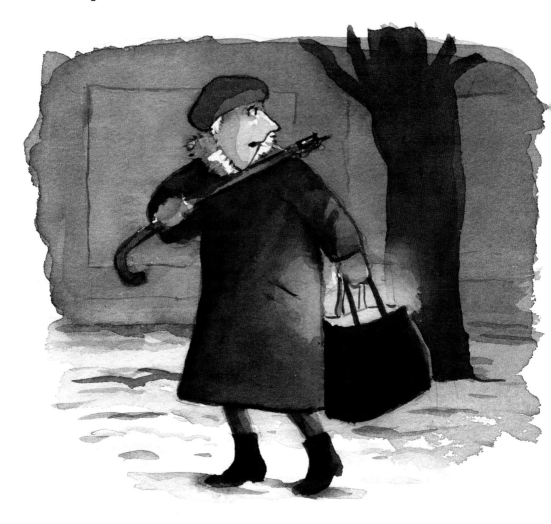

1

KARIN SÖDERGREN ILLUSTRATION **ADDRESS** KATARINA BANGATA 40, SE-116 39 STOCKHOLM, SWEDEN
PHONE +46 (0)8 641 44 69, +46 (0)70 721 41 72 **E-MAIL** KARIN.FOX@TELIA.COM **WEBSITE** WWW.SKETCHBOOK.NU
SPECIALITY CHILDREN'S BOOKS ILLUSTRATION, EDUCATIONAL MATERIAL, MAGAZINE ILLUSTRATION
CLIENTS BOKFÖRLAGET OPAL, LIBER, EGMONT, THE PLASTICS & CHEMICALS FEDERATION

362

3

1 PER PENNA. ILLUSTRATION FOR THE READERS' OWN STORIES. HEMMETS JOURNAL, 2006
2 THE ENVIOUS SISTERS. "SAGOR – TUSEN OCH EN NATT". BONNIER UTBILDNING, 2006
3 KING MAMUD AND THE PIE BAKER. "SAGOR – TUSEN OCH EN NATT". BONNIER UTBILDNING, 2006

Sara Teleman

1

SARA TELEMAN GRAFISK DESIGN & ILLUSTRATION **ADDRESS** KOCKSGATAN 24, SE-116 24 STOCKHOLM, SWEDEN
PHONE +46 (0)8 643 89 52, +46 (0)73 324 24 22 **E-MAIL** SARA@SARATELEMAN.COM **WEBSITE** WWW.SARATELEMAN.COM
SPECIALITY CHILDREN'S BOOKS ILLUSTRATION, PORTRAITS, SUPPLYING BOTH ILLUSTRATION AND TEXT
CLIENTS SVENSKA DAGBLADET, DDB STOCKHOLM, PARASOLL FÖRLAG, BONNIER FAKTA, RABÉN & SJÖGREN

1 PORTRAIT OF CLUB MUSICIAN UFFIE. SVENSKA DAGBLADET, 2006
2 FEATURE ON MIDSUMMER NIGHT'S EVE. SVENSKA DAGBLADET, 2006

3 PORTRAIT OF JOCKE, CLUB HOST AT DEBASER. SVENSKA DAGBLADET, 2006
4 PORTRAIT OF GRAFITTI ARTIST T-KID. SVENSKA DAGBLADET, 2006

Catharina Tham

1

CATHARINA THAM **ADDRESS** KOCKSGATAN 24, SE-116 24 STOCKHOLM, SWEDEN
PHONE +46 (0)8 643 10 90, +46 (0)70 984 40 80 **E-MAIL** CATHARINA@CTHAM.SE **WEBSITE** WWW.CTHAM.SE
SPECIALITY BOOK ILLUSTRATION, MAGAZINE ILLUSTRATION, PUBLIC COMMISSIONS **CLIENTS** KING LILY, ARLA,
VIN & BAR, TIDEN FÖRLAG, RABÉN & SJÖGREN

1 GENTLEMAN AND FRAME. KING LILY, 2007 2 FASHION ILLUSTRATION FOR WEBSHOP. KING LILY, 2007

Udos / Marit Mossbäck, Gunnar Fernlund

1

UDOS **ADDRESS** IVAR HALLSTRÖMS VÄG 6, SE-129 38 HÄGERSTEN, SWEDEN
PHONE +46 (0)8 708 90 07, +46 (0)70 409 33 92 **E-MAIL** GUNNAR@UDOS.SE **WEBSITE** WWW.UDOS.SE
SPECIALITY ANIMATION, FILM AND VIDEO, GRAPHIC DESIGN

Cecilia Undemark

1

UNDEMARK FORM **ADDRESS** MOSEBACKE BILD, HÖGBERGSGATAN 28, ÖG, SE-116 20 STOCKHOLM, SWEDEN
PHONE +46 (0)70 518 64 92 **E-MAIL** CECILIA@UNDEMARK.SE **WEBSITE** WWW.UNDEMARK.SE
SPECIALITY ADVERTISING, GRAPHIC DESIGN, MAGAZINE ILLUSTRATION **CLIENTS** GOTHENBURG UNIVERSITY,
THE SWEDISH COMMITTEE AGAINST ANTISEMITISM, THE JEWISH CHRONICLE, AMELIA, HILLELFÖRLAGET

73

Eva-Marie Wadman

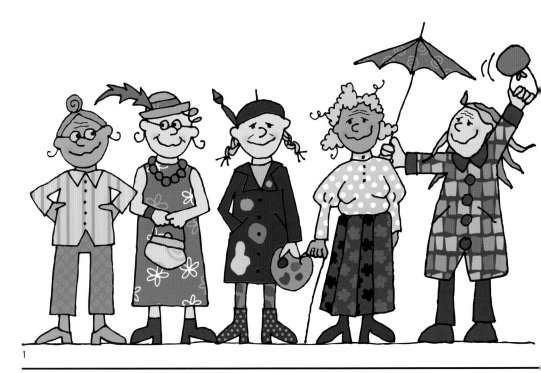

1

E&T WADMAN AB **ADDRESS** TIMMERMANSGATAN 43, SE-118 55 STOCKHOLM, SWEDEN
PHONE +46 (0)70 635 88 08 **E-MAIL** WADMANS@ALGONET.SE **SPECIALITY** BOOK COVERS, CHILDREN'S BOOKS
ILLUSTRATION, EDUCATIONAL MATERIAL **CLIENTS** GLEERUPS UTBILDNING, VERBUM FÖRLAG, STOCKHOLM COUNTY COUNCIL,
GOTHIA FÖRLAG

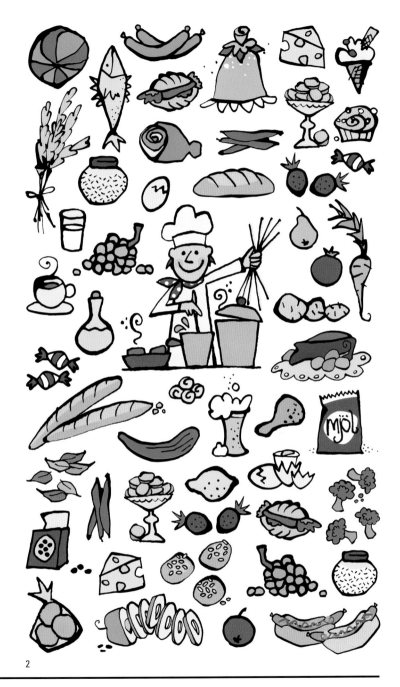

2

1 FIVE OLD LADIES. "LÄSKATTEN SIXTEN". CHILDREN'S TEXTBOOK. GLEERUPS UTBILDNING, 2006
2 COOKBOOK ILLUSTRATION. GOTHIA FÖRLAG, 2006

Pontus Wahlström

1

PONTUS DESIGN **ADDRESS** STORA NYGATAN 44, SE-111 27 STOCKHOLM, SWEDEN
PHONE +46 (0)8 720 60 88 **WEBSITE** WWW.STOCKHOLMILLUSTRATION.COM, WWW.PONTUSDESIGN.SE
E-MAIL PONTUS@STOCKHOLMILLUSTRATION.COM **SPECIALITY** ANIMATION, CONCEPTUAL DRAWING, LOGOTYPES
CLIENTS LIBER, H. ASCHEHOUG & CO, UR, ARLA FOODS, MINISTRY OF EDUCATION, RESEARCH AND CULTURE

1 MATRIKS. ILLUSTRATION AND ANIMATION FOR WEBSITE WWW.LOKUS123.NO/MATRIKS. H. ASCHEOUG & CO, 2006
2 EMPIRE STATE BUILDING. MILK CARTON PANEL. ARLA FOODS, 2005

3 PURIM. "VÄRLDENS FEST I SVERIGE". BOOK. UR FÖRLAG, 2005
4 MAGAZINE ILLUSTRATION. ARBETSMARKNADEN/AMS, 2007

4

Cecilia Waxberg

1

© WAXBERG **ADDRESS** GUSTAV ADOLFS TORG 10 B, SE-211 39 MALMÖ, SWEDEN
PHONE +46 (0)40 66 55 796, +46 (0)70 723 16 14 **E-MAIL** CECILIA@WAXBERG.M.SE **WEBSITE** WWW.WAXBERG.M.SE
SPECIALITY ADVERTISING, MAGAZINE ILLUSTRATION, PUBLIC COMMISSIONS **CLIENTS** CITY OF MALMÖ, E.ON ENERGY,
IKEA, LIBER, SONY ERICSSON **AGENCY** AFLO (JP)

1 "SWEDEN". COASTERS. CINDOR, 2005
2 "THE LANGUAGE JOINS". TEXTBOOK FOR SWEDISH AND DANISH PUPILS. CITY OF MALMÖ, 2003

Boel Werner

1

BOEL WERNER **ADDRESS** KRABO, RÄFSNÄSVÄGEN 27, SE-771 94 LUDVIKA, SWEDEN
PHONE +46 (0)240 174 58, +46 (0)73 536 24 36 **E-MAIL** BOEL@BOELWERNER.COM **WEBSITE** WWW.BOELWERNER.COM
SPECIALITY CHILDREN'S BOOKS ILLUSTRATION, EDUCATIONAL MATERIAL, SUPPLYING BOTH ILLUSTRATION AND TEXT
CLIENTS BONNIER-CARLSEN, RABÉN & SJÖGREN, ALFABETA PUBLISHERS, LL-FÖRLAGET, BOKFÖRLAGET OPAL

1 "PAPPARESAN". CHILDREN'S BOOK. COVER. BOKFÖRLAGET OPAL, 2007
2 MY BROTHER SWIMMING. CHILDREN'S BOOK ILLUSTRATION. OWN PROJECT, 2006

4

5

3 CATALOGUE COVER. FOLKETS HUS OCH PARKER, 2005
4–5 "PAPPARESAN". CHILDREN'S BOOK. BOKFÖRLAGET OPAL, 2007

Jenny Wik

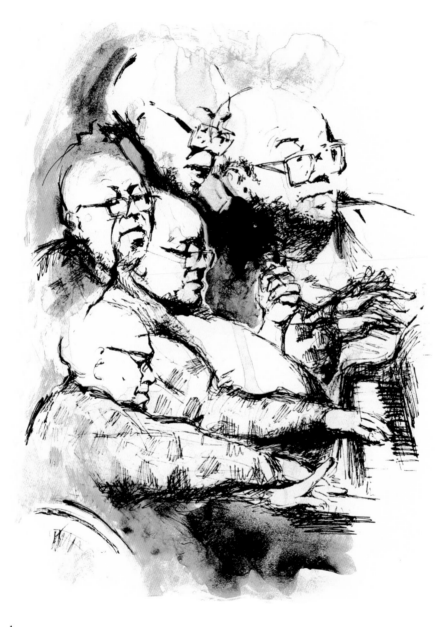

1

JENNY WIK **ADDRESS** TAUBEGATAN 2 B, SE-414 55 GÖTEBORG, SWEDEN
PHONE +46 (0)31 24 78 01, +46 (0)70 720 72 97 **E-MAIL** JENNY@WIK.CC **WEBSITE** WWW.HOLOSDESIGN.SE
SPECIALITY BOOK ILLUSTRATION, MAGAZINE ILLUSTRATION, PORTRAITS

1 PORTRAIT. LIRA MUSIKMAGASIN, 2006 2 CHILDREN'S BOOKS ABOUT THE CHARACTER ELLIS. ICA BOKFÖRLAG, 2007

Helena Willis

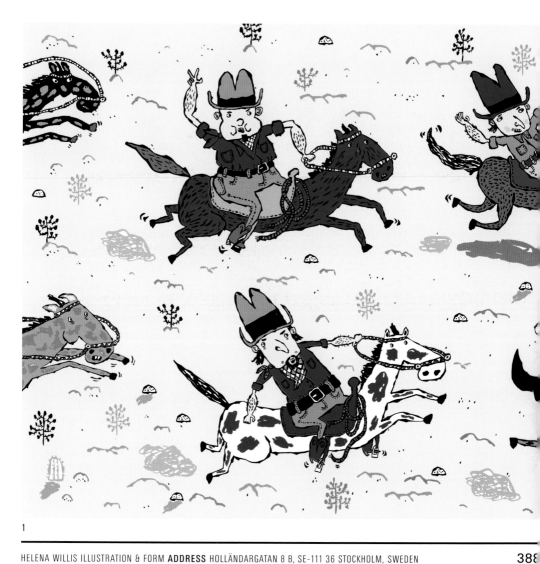

1

HELENA WILLIS ILLUSTRATION & FORM **ADDRESS** HOLLÄNDARGATAN 8 B, SE-111 36 STOCKHOLM, SWEDEN
PHONE +46 (0)8 546 60 715, +46 (0)70 714 97 15 **E-MAIL** HELENA@KOMBINERA.SE
SPECIALITY BOOK COVERS, CHILDREN'S BOOKS ILLUSTRATION, MAGAZINE ILLUSTRATION
CLIENTS BONNIER CARLSEN, RABÉN & SJÖGREN, BOKFÖRLAGET NATUR & KULTUR, TIDEN FÖRLAG

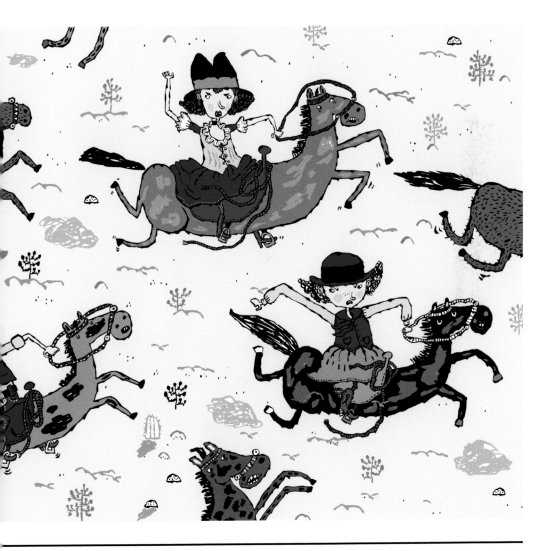

 1 "OLGA KASTAR LASSO". CHILDREN'S BOOK. RABÉN & SJÖGREN, 2006

Stina Wirsén

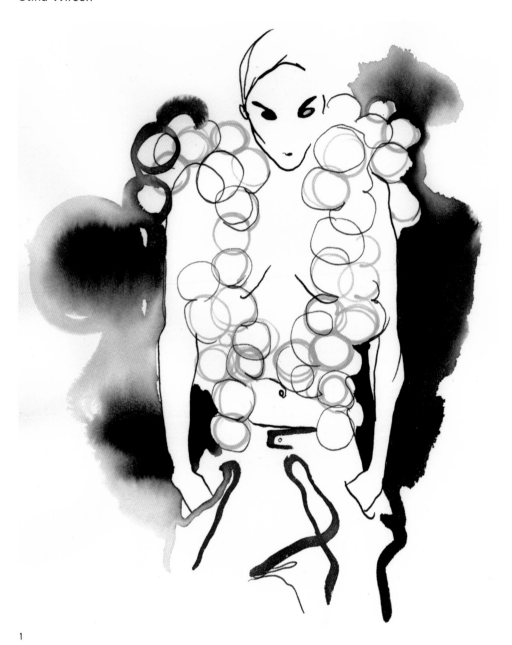

1

STINA WIRSÉN BILD AB **ADDRESS** BRÄNNKYRKAGATAN 13, SE-118 20 STOCKHOLM, SWEDEN
PHONE +46 (0)8 31 48 64, +46 (0)70 620 10 64 **WEBSITE** WWW.STINAWIRSEN.COM
SPECIALITY BOOK ILLUSTRATION, FASHION ILLUSTRATION, MAGAZINE ILLUSTRATION
AGENCY SNYDER & CO (USA)

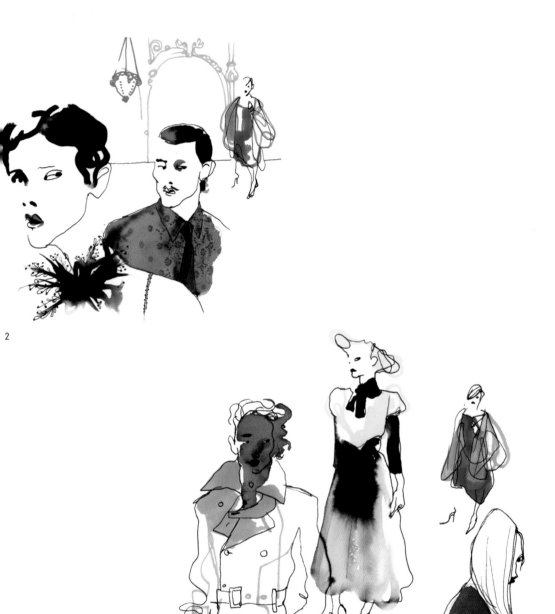

2

3

1 WOOL AND MOHAIR TOP BY SANDRA BACKLUND 2 BRIC A BRAC. STOCKHOLM FASHION WEEK, 2006
3 STOCKHOLM FASHION WEEK, 2006

Anna Ågrahn

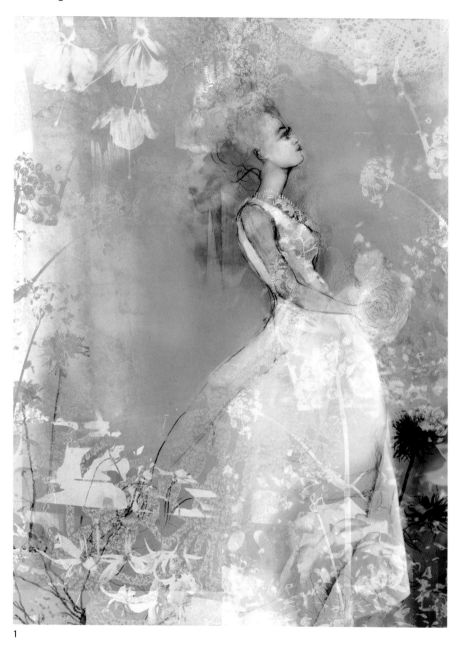

1

ANNA ÅGRAHN **PHONE** +46 (0)70 611 45 85 **E-MAIL** ANNA@AGRAHN.COM **WEBSITE** WWW.AGRAHN.COM
SPECIALITY BOOK ILLUSTRATION, MAGAZINE ILLUSTRATION **CLIENTS** ACCENT/IOGT-NTO, UPSALA NYA TIDNING,
FOLKET I BILD, VÄSTERBOTTENS-KURIREN, SPIRA/CHURCH OF SWEDEN

2

3

1 BRIDE. SELF PROMOTION, 2006 2 TEAR IN MY BEER. COUNTRY MUSIC AND ALCOHOL. ACCENT/IOGT-NTO, 2007
3 STINA. ILLUSTRATED SHORT STORY. FOLKET I BILD, 2005

5

6

4 SELF PROMOTION, 2005 **5** GREEDY RECORD COMPANIES. VÄSTERBOTTENS-KURIREN, 2005
6 TO BEHAVE IN THE BAR. UPSALA NYA TIDNING, 2005

Marie Åhfeldt

1

MÅS ILLUSTRA **ADDRESS** KVARNGATAN 3 B, ÖG, SE-118 47 STOCKHOLM, SWEDEN
PHONE +46 (0)8 615 15 39, +46 (0)70 480 06 50 **E-MAIL** ILLUST@ALGONET.SE
SPECIALITY BOOK COVERS, EDUCATIONAL MATERIAL, MAGAZINE ILLUSTRATION
CLIENTS FEMINA, VÅRDFACKET, LÄRARNAS TIDNING, BOKFÖRLAGET NATUR & KULTUR, LIBER

2

Sara Ånestrand

1

SARA Å DESIGN **ADDRESS** EKLÅNGSVÄGEN 42, SE-120 51 ÅRSTA, SWEDEN
PHONE +46 (0)8 722 87 55, +46 (0)73 642 30 90 **E-MAIL** SARA.DESIGN@HOME.SE
SPECIALITY BOOK COVERS, BOOK ILLUSTRATION, GRAPHIC DESIGN
CLIENTS LIBER, BONNIER UTBILDNING, ART PLATFORM, NEMO ARKITEKTER

2

3

 1–3 "FÖRSTA HJÄLPEN TILL BARN". BOOK. LIBER, 2005

SPECIALITIES

STORYBOARDS

SUPPLYING BOTH
ILLUSTRATION AND TEXT

TECHNICAL ILLUSTRATION